Photolab
Design *for Professionals*

Photolab Design FOR PROFESSIONALS

CONTENTS

Photolab Design

INDIVIDUALITY

The material in this book represents years of experience of many experts in planning and designing professional photolabs. The design of a lab is highly individualized; no two are alike. Use this book in consultation with an architect, a consulting engineer, or a building contractor so that he or she can provide for your special needs. The photolab that you plan may be as simple as a single room for developing black-and-white film and making prints or as complex as a complete facility for color film processing, printing, finishing, and framing.

Careful planning will make your operations more efficient. Because of new equipment designs, especially in processors, we thoroughly discuss light rooms, too. When planning your lab, include peripheral operations such as copying, laminating, and retouching.

The needs of professional photographers, photofinishers, industrial photographers, researchers, and others who do their own photographic processing are extremely diverse. This diversity and the space requirements for each operation make it impossible to present plans that suit every situation. However, processing rooms have many features in common, regardless of how you use photography. Therefore, we treat basic requirements and construction in a general way in Section II, "Design." Planning for specific needs is covered in Section III, "Detailed Planning."

If you are an architect, you will notice that Section III parallels the organization of the appropriate sections of *Masterformat,* jointly produced by the Construction Specifications Institute (CSI) and Construction Specifications Canada (CSC). *Masterformat* is commonly used to organize construction documents and literature, such as *Masterspec* and *Sweet's Catalog File.*

All lab operations think of themselves as customer-conscious; it is equally important to be employee-conscious. Attractive lunchroom and restroom facilities will make your workers feel appreciated. They will respond with higher productivity. Access for personnel and customers in wheelchairs, and modifications for other handicaps, such as blindness and deafness, will gain you skilled employees, more customers, and a reputation as a progressive business.

If you are building a new lab, you have the opportunity to design your lab from the ground up. But even if you are not going to build a new facility, you can learn about remodeling from the collection of photolab plans in Appendix B of this book. You may even decide that modern appointments can upgrade your present work area so that a new facility is not necessary.

SYSTEMATIC PLANNING

Organize your planning efforts. Before you consider the details of laboratory layout and construction, look at your immediate and future needs. What will be the volume of work in three years? In five years? In ten years? Will the nature of your business change? How so? Compile data and production requirements, business growth, and economic trends in your business segment.

With such information, you can discuss your needs with realtors, engineering consultants, and architects. For example, an architect will be interested in capacity, i.e., the number of prints produced per hour or the number of people in the lab. From this data, the architect can determine how much space you need. Ultimately, these professionals can help you to decide whether to build, buy, lease, or remodel. These considerations must be integrated with the requirements dictated by available locations: utilities, topography, transportation, land and code restrictions, and labor.

After you decide whether to remodel or relocate, you can plan your facilities. One way of thinking about this planning phase is "from the outside in." Use the data that you've assembled to—

- Assess the volume requirements
- Define the production areas
- List the machines and equipment

When you determine volume and equipment, you can determine the sizes of areas and arrange them for efficient workflow. By balancing workflow with space utilization, you can lay out the general location of laboratory functions.

Begin planning the details by making a diagram of operation sequences. Combine similar operating functions to make efficient use of equipment. As the equipment is located, give thought to the possibilities for future expansion. Your architect will assist with the details of plumbing, electrical, and waste-line service. Group darkrooms or equipment to minimize costs of installing utilities.

In the final planning stages, you will become more involved with the architect, contractor, banker, and municipal authority. Building, space, or land purchase will require the attention of all these people. The architect or contractor will produce working drawings, and these in turn will go to the banker and governmental authority. The contractor must submit an estimate or the architect may ask several contractors to bid on your laboratory. Your banker must consider the plans, the costs, and your financial position. Ultimately, though, you are the decision-maker. You must be prepared to act. This book will help prepare you to make the right decisions.

Professional Lab Portfolio

Sentry Color Labs Ltd.

A quote from Sentry's promotional folder reads: "The house that color built."
Indeed, this full-service lab has been built on a wide range of color as well as
black-and-white processing services. Established in 1973, this lab has had tremendous growth because of its innovative approach to customer service and quality.

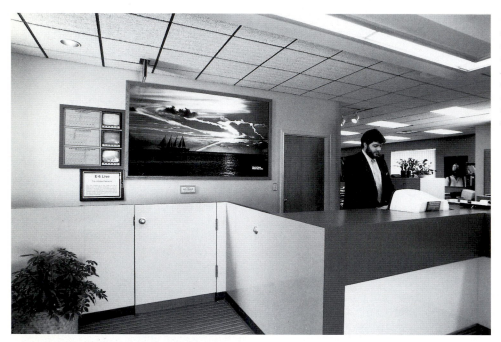

The reception area includes computers for logging in customer orders, a backlit display made on KODAK DURATRANS Display Material, and a series of infrared television monitors that show machine activity for three different processes.

Bright and spacious, the break room provides a pleasant atmosphere for coffee breaks and "brown-bag" lunches. Amenities include a microwave oven, a beverage vending machine, and a refrigerator. Food-oriented photo decor on the wall adds a nice touch to this attractive, inviting area.

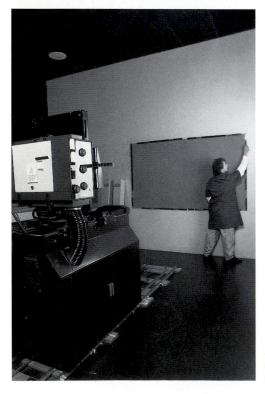

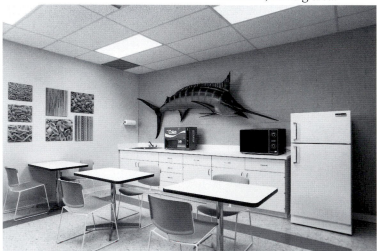

The camera room has a metal wall with strip magnets to hold film or paper during exposure of photomurals.

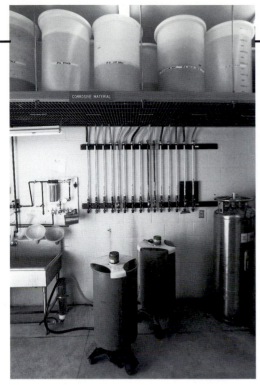

The chemical-mixing area allows easy access to elevated storage tanks. Note the nitrogen supply tank for nitrogen-burst agitation in color processing.

The print-viewing area is located in the center of the lab for easy access and efficient workflow. Overhead illumination provides the appropriate color temperature for print evaluation. Deep, sloping counters facilitate print viewing.

Laminating machines for photomurals are in the large center area of the lab. Supplies for lamination are on an adjoining wall for easy access.

Sensitized-goods storage is in a separate temperature-controlled room centrally located to darkrooms within the lab. Paper is organized by trim size and surface texture to speed production flow.

Professional Lab Portfolio

James Scherzi Photography, Inc.

This professional studio has complete darkroom facilities adjoining the shooting area for the ultimate in convenience and quality. Jim Scherzi designed this high-tech facility from experience gained in two previous studio locations. The result is nothing short of spectacular.

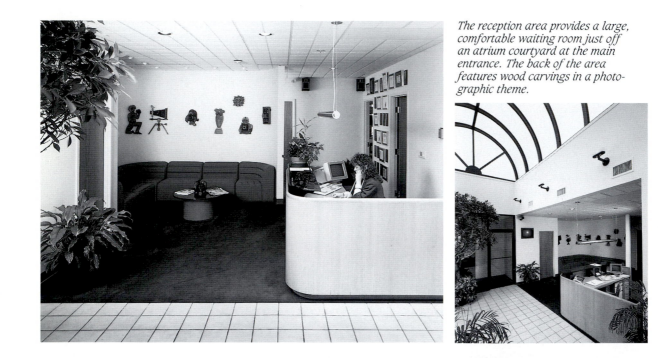

The reception area provides a large, comfortable waiting room just off an atrium courtyard at the main entrance. The back of the area features wood carvings in a photographic theme.

Main studio area viewed from the kitchen. The large door to the left allows vehicle access to the floor for moving large objects; the center doors lead to the film-loading darkroom and printing darkrooms. The doors on the right open into dressing /restrooms and the offices of the studio.

The film-loading room has compressed air piped in from a central location (this system also serves all other darkrooms). A refrigerator provides convenient access to film supplies. The studio is reached by a rotary-type door; another door opens into a "dark" hallway with access to all darkrooms.

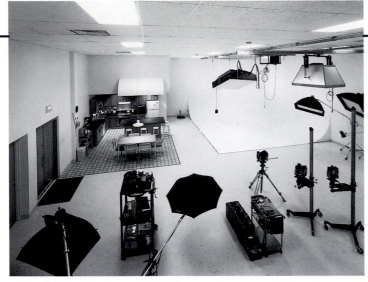

View of the studio floor with food-preparation area on left and cyc (see Glossary) on the right. Large backdrops are stored upright behind the kitchen area. A hanging remote-control unit allows photographers to move softboxes mounted on ceiling tracks.

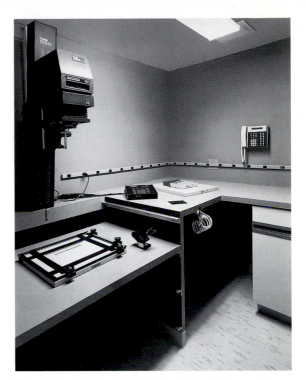

The enlarger in the color-printing darkroom has a drop base for making big enlargements. The room is equipped with a telephone and compressed air. Strip-track electrical plugs around the room make outlets available in any location.

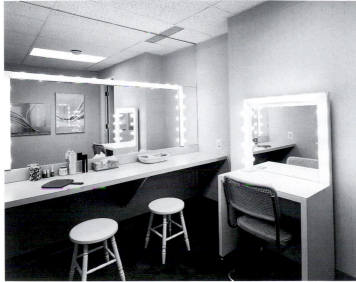

The women's dressing room has theatrical strip lights around mirrored surfaces; the restroom adjoins.

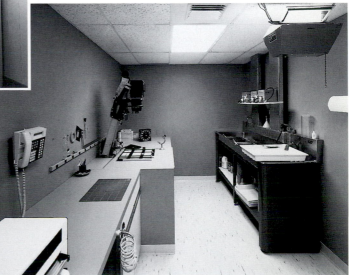

The black-and-white printing and processing darkroom has a custom-built ventilation hood over the processing sink. Easy dispensing of chemicals is available from Cubitainers on a shelf mounted around the hood.

Professional Lab Portfolio

Professional Imaging Laboratories, Inc.

Professional Imaging prides itself in niche marketing and unique equipment modification. They have focused on specialty customers: photographers shooting proms, dance schools, weddings, portraits, and sports. They provide a variety of print packages to attract photographers too busy to make their own prints. The lab has fabricated or modified many pieces of hardware to serve its clients better. Furthermore, all of this is done in a very small, yet efficiently organized space.

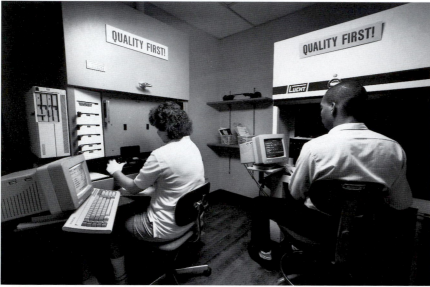

Automatic color printers are grouped together to save space. Printer monitors are custom-mounted so that operators can view and evaluate negatives more easily.

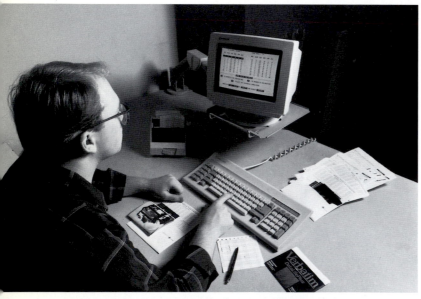

Customer prints are reviewed for deviations from quality standards; printer corrections are recorded onto a floppy disk for reprints.

The color-negative processor and dry-end inspection area are isolated from the printing areas by a glass wall/door partition for cleanliness and environmental control.

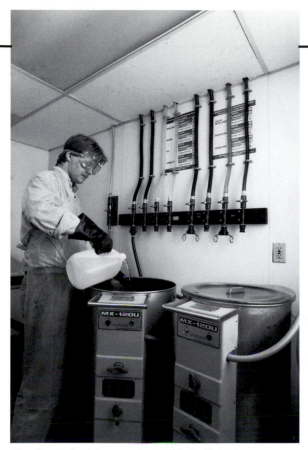

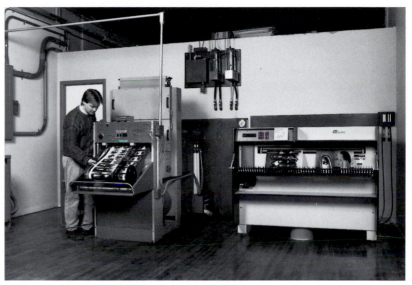

The chemical-mixing area is small but efficient. Quick-disconnects allow solutions to be pumped to an upper level for storage and ultimately for gravity feeding to the machines.

Medium- and large-format papers are processed through separate machines from a single darkroom behind this wall. Space above and to the rear of the machines is dedicated to chemical supply.

A custom-designed negative cutter sleeves film into envelopes to complete customer orders.

Section I Preliminary Planning

The more time you spend carefully planning your needs, the more efficient your design will be. The benefits of good design are far-reaching; the disadvantages of poor design can be costly in many ways and eventually can lead to expensive reconstruction.

The complexity of a construction or modernizing project depends on its size and on the number of different operations it contains. If you need only a small darkroom in a professional studio or a small in-plant photographic department, you can design the room yourself and have the contractor build to your specifications. The information in this book will help you choose and specify suitable materials for floors, walls, ceilings, fixtures, plumbing, and to some extent, the electrical installation. You can use one of the suggested layouts in this book as a basic design or adapt it to your specific needs.

If the project is large, you will need the services of an architect. An architect can design both the outside and the inside of the building, or draw up specifications and final plans based on your preliminary layout. Remember that the architect may have no special knowledge of photographic work, so work with him closely to avoid serious mistakes. An important function of the architect is to acquaint you with local building codes, zoning ordinances, and safety regulations. At the same time, he can provide a preliminary cost estimate. This is important, because you must know as soon as possible what the program will cost so that you can be sure that sufficient funds are available. If they are not, modify your plans accordingly.

For an extensive project, consult with an industrial engineer. He can use the available space to the best advantage and place equipment for the most efficient workflow.

Start your planning by posing a series of questions that you will have to answer as your planning proceeds. These questions are basic to a "needs analysis" and the answers will clarify your planning. Answer the following questions before you start preliminary design and before you discuss your plans with an architect, building contractor, realtor, or banker:

What kinds of operations will the photolab include?
Black-and-white film processing?
Black-and-white printing?
Color film processing?
Color printing?
Retouching?
Print trimming/finishing/laminating?
Copying?
Framing?
Film sales?

What will the work volume be?
How many employees in the lab?
How much room do I have or will I need?
Is efficient workflow or space utilization more important to me?
Is location important?
What type of building is suitable?
Will I need mechanized equipment or can I do operations manually?
Are adequate utilities readily available?
What are my financial resources?
Can I anticipate changes in my lab operation due to a changing market for my services?
Will my new facility provide a return in increased profit, better service, or increased production?

RESEARCH

Once you've answered the questions above, you can start gathering facts and figures to estimate the size and scope of your new lab.

Divide your research efforts into (1) site, (2) location factors, and (3) internal needs. Consider the planning phase for the photolab "from the outside in" and the design phase "from the inside out."

The Site

Study the effects of location on your business. Is your site accessible to commercial traffic? Consumer traffic? Postal service? Public transportation? Consider your site from your customer's viewpoint. Are you in a suitable neighborhood? Is it convenient to your customers? Will there be sufficient parking space? Must customers come to your laboratory? Will you provide pick-up and delivery service? Is this economical from your location?

Another consideration is the availability of "quality" water (see page 37). Excessive dissolved solids can inhibit quality photo processing. The dissolved solids in well water are almost untreatable for photographic processing. Avoid sites that rely on well water.

With a completely new studio or a new processing lab, you have the opportunity to design and locate the whole plant to suit your needs. On the other hand, if you propose to modernize an existing setup or transfer your activities to another building, your choice of location and design may be restricted by the availability of suitable buildings. Or you may have to search for a building based on general requirements for floor space and services.

Location Factors

If you are setting up a portrait studio, you are in the same situation as most retailers. Location is paramount. Decide on a site only after carefully studying all the circumstances.

For example, the proximity of industrial plants may bring excellent trade to a restaurant or a convenience store, but be of little value to the portrait photographer. On the other hand, if your studio is close to a military base or a college, you are near people who are away from home. This usually means good business for a portrait photographer.

The character of surrounding businesses or industries bears on the location of your laboratory. You would not be wise to locate your laboratory near a heavy manufacturing industry or a chemical plant from which you might get smoke, particles, or airborne chemical pollutants. The costs of filtering your laboratory air could be prohibitive. Use these same criteria in locating a laboratory within a building. If you isolate the laboratory from traffic areas, furnace rooms, warehouses, and other dirt-producing areas, you will have less trouble with dust and dirt.

Also consider vibration from trains, subways, or heavy vehicles on nearby

expressways. This type of vibration is difficult to isolate and eliminate.

Utilities—electricity, gas, water, waste disposal—must be readily available and adequate for your needs. Review the section "Detailed Planning" as a guide to the quality and capacity of the services you will require. Find out what codes govern the type of facility you are planning.

Internal Needs

When you have gathered enough information on the location and services needed for your photolab, assess space requirements. You can approach this analysis with one of two viewpoints: "This is the space I have. Now what can I put in it?" Or "How much space will I need for the activities I want to undertake?"

Make a checklist of the functions you will include. Find out how much space you have to allot for each function. You can judge from plans in this book, from your present facilities or your own experience, and from details provided by equipment manufacturers. See page 13 for a sample checklist.

The type of business or photographic processing service will influence space needs. For high-volume production, assign a generous area for all processes to avoid hindrances to the flow of work. Where rapid processing is necessary, as in newspaper operations, a compact, efficient setup may speed the production of finished prints.

To assess space requirements, you need to define the number and type of processes you will include in the photolab. You should also decide, along with the personnel requirements, whether to do manual processing, batch processing, or automatic machine processing. Typically, machine processing will require fewer people and less space. See the notes on equipment in Section II, "Design," for information on planning for mechanization.

CONSULTATION

In planning for photolab construction, you can proceed part of the way on your own. You can assess your own needs and research those areas to which you have personal access. However, you will want the aid of the professionals listed below.

The scope of your plan will determine which consultants you should

consider. For construction of a small laboratory or remodeling of your present one, you may need only a building contractor. If you have more extensive plans, however, you should find out what services you can obtain from each of the following professionals.

Architect

When you retain an architect, you are obviously looking for professional design services. The architect can also offer other services. As part of the design and cost estimating that the architect does, he can, and in many cases must, determine zoning and building codes, pollution-abatement requirements, fire protection, and other required standards. He can also solicit bids and administer the construction contract. For more details on hiring an architect, see Appendix A.

Building Contractor

The contractor is the building expert who will be responsible for the proper construction of your photolab. He will establish costs (often in consultation with the architect), carry out construction, install equipment, and handle finishing details. Under his direction, workers or subcontractors will observe code restrictions and use accepted construction methods.

Municipal Authority

In many communities, this official has the responsibility of overseeing building codes, zoning restrictions, and waste management. It is most important to check with your local governmental authority before you start planning a new facility. A key element of the planning is obtaining a discharge permit as soon as possible so that you can be sure the installation is within local standards. You should also become familiar with the local codes and statutes governing your site and building.

Real-Estate Agent

If you are relocating your photolab to a new or existing building, a Realtor can assist you in several ways. Most importantly, a Realtor can find suitable sites or buildings for you. A commercial Realtor may provide such services as a site analysis based on your business requirements of access, customer parking, services, cost, taxes, and other factors. In many cases, a Realtor

can offer assistance with or referrals to financial help.

Lawyer

Legal assistance is necessary whenever you discuss contracts for real-estate acquisition, building, or finance. A lawyer will also advise you about your obligations under business laws and on taxes and insurance.

Banker

Unless you can finance your photolab construction or remodeling from current profits or have an independent funding agency, you will have to find a source for the required funds. A banker can advise you on loans and options for financing.

Photo Reps and Dealers

A valuable source of aid for planning your photolab is the manufacturer or dealer in photographic equipment and supplies. He is interested in your success in running an efficient and profitable lab. He can assist you in selecting and evaluating equipment and setting up the required processes.

Professional or Trade Association

Some groups may provide direct help in lab planning as a membership service. Even if the group has no such service, you can get information and ideas through discussion at meetings and seminars.

Kodak helps in your photolab planning by presenting this and other books to provoke thought and provide information; through technical sales representatives who can make an on-the-spot assessment of extensive photographic needs; and with professional planning assistance from the Facilities Design Department of the Professional Photography Division. Ask your Kodak Technical Sales Representative about the design assistance that this group can offer.

Industrial Engineer

In establishing an extensive business, such as a large photofinishing plant, it may be wise to contact a consulting industrial engineer. The industrial engineer is expert in efficient process methods, workflow, and cost-effective systems analysis. He can advise you on equipment utilization, output, and efficiency.

11

Section II Design

LAYOUT

When you have decided on your needs, make a preliminary layout. This layout can be the basis for discussion with your architect or contractor. From it, he can begin to make detailed plans and draw up specifications for construction.

To start the layout, make a checklist similar to that given on page 13. Check each area that applies to your work and make a separate list of the equipment and fixtures that will be in each room. Using templates and grid paper, follow the procedure described below to calculate the space needed for each room. Enter these areas (in square feet) on the checklist. This will show the total space needed.

To find the amount of space needed for each room, cut scale templates of all the equipment and fixtures that you intend to use. Make the templates to a scale of ¼ inch to 1 foot, and lay them out on a sheet of paper ruled in ¼-inch squares. Each square represents 1 square foot of floor space. Use this method to indicate the area needed for equipment or to indicate how well the equipment will fit limited floor space.

To make a layout in metric units, use a scale of 1 centimetre to 1 metre, and use centimetre grid paper. Use of metric equivalents here is for the convenience of readers who may require them. It does not imply any architectural standards based on metric dimensions.

In making these estimates, remember to allow room for free movement of operators around the sinks, benches, and equipment. In the case of machinery, allow space for safe operation as well as access for cleaning, repairing, or servicing the unit.

When you calculate the dimensions, remember that some operations may require extra space for handling materials. For example, more room is needed at a sink where big enlargements are processed.

When you have determined the dimensions of each room, combine the layouts of each area. Lay the templates on a large sheet of grid paper on which you have outlined the total space available. Remember to leave space for corridors and for free access to workrooms.

The following discussion of workflow will help you to lay out the operations so that work flows naturally from one stage of production to the next.

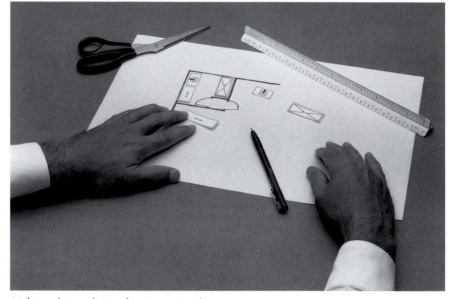

Make scale templates of equipment and arrange them on grid paper to determine efficient placement in the workrooms.

Layout Checklist

Room	No. Required	Approximate Minimum Size	
		Length x Width	Square Feet
Reception			
Offices			
Dressing			
Accounting/computer			
Prop storage			
Sensitized-goods storage			
Chemical storage			
Rest rooms			
Utility/maintenance			
Lunchroom			
Studio or camera			
Finishing			
Copying			
Chemical mixing			
Quality control or viewing			
Film-loading darkroom			
Black-and-white film darkroom			
Color film darkroom			
Black-and-white printing darkroom			
Color printing darkroom			
Shipping/receiving			
Conference			
Album assembly/mounting/framing			

Planning Notes:

1. If only one operator works in a room, allow about 30 to 36 inches (75 to 90 centimetres) of space between benches or between bench and sink for free movement.

2. If two operators work together, allow about 36 to 42 inches (90 to 105 centimetres) of space for free movement.

3. If more than two people work together, allow at least 48 inches (120 centimetres) of space where they must pass one another or use a common hallway.

4. A corridor that carries general traffic or that is the main route to a fire exit should be at least 60 inches (150 centimetres) wide.

WORKFLOW

To avoid wasted time and energy caused by backtracking and cross flow, place operations so that they follow each other in the order in which they are performed. The following chart will help with the location of workrooms and placement of equipment.

For example, in a photofinishing plant where a job may have to be completed on the day it is received, efficient and orderly flow of work is vital. Work must be kept moving at all times.

Appropriate positioning of equipment in the photolab includes more than the personal desires of the operator. The equipment should be placed so that it contributes to smooth workflow and does not reduce the production rate. Workers should not have to queue up to run their work through a processor, for instance.

Naturally, you should place equipment where utilities are readily available. If you design your lab with this in mind, you won't encounter problems with insufficient electrical capacity. Keep in mind that electrical power can be brought to equipment, but drains are difficult and costly to move.

To plan for the installation of equipment, consult the photolab plans in Appendix B. These plans give a general idea of the floor space needed for various printers, processors, and allied equipment. For details on service requirements for a particular Kodak machine, ask your Kodak Technical Sales Representative for service information.

In a small studio or an in-plant photographic department, fitting the equipment into the smallest possible space or making each piece of equipment do as many jobs as possible may overrule workflow requirements.

Start by checking orders in at an order-control point, and then route them to the appropriate production section, where they merge with the general flow of work. Plan production so that it proceeds in one direction only in an uninterrupted cycle that ends at a dispatch point near the order-control desk.

Each operation must be manned and equipped to cope with the load from the preceding operations. Otherwise, a backlog of orders will interrupt the workflow, and the output of the whole operation will be reduced to that of the slowest section.

Ideally, the sequence of steps in photographic production should follow the pattern indicated by the workflow chart below. However, you may have to modify the pattern to suit the shape of a particular workspace, to balance work load, or to accommodate individual operating requirements.

Workflow Chart

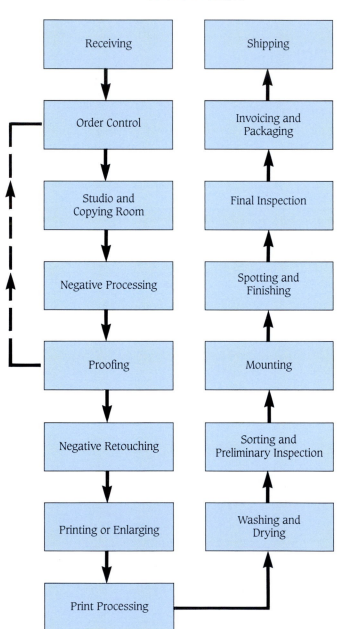

EQUIPMENT

During design of your lab, choose equipment that will be permanently installed—sinks, cupboards, heating and air-conditioning units, and the like. Your architect or contractor can assist you, but assessing your photographic needs and selecting equipment is your responsibility.

Compare your current workload and anticipated future expansion with the capacity of equipment advertised by the manufacturer. Your choice of equipment should also reflect the needs of the user and may take into account your personal preferences as the owner or manager of the laboratory.

Justification

First decide if you need more equipment. Should you add capacity or equipment to run a new process, or should you send the work out to a specialist? Answer this question before deciding to purchase equipment.

Then consider the alternatives of manual handling or mechanization. Consider the requirements for trained personnel, space, productivity, cost, and convenience.

If you decide to mechanize, gather data on the machines or processors that can perform the functions you require. Manufacturers provide detailed analyses for their equipment. What is the widest material it will handle? How much material will it handle per hour? What maintenance will it require? What is the price? Does this include necessary accessories? On the basis of the projected output (and expected profit), how long will it take to amortize the cost? Cost aside, is convenience alone reason enough to buy the equipment? Is rapid turn-around a requirement of your business?

Supporting Equipment

Don't underestimate accessory equipment needed to support the prime pieces. Consider an enlarger. In addition to the enlarger, you need a selection of lenses (and perhaps matching condensers), a color head, a voltage stabilizer, a timer, an on-easel photometer, a static eliminator, a grain magnifier, and an easel. The enlarger is of little use without many or all of these accessories; their cost may exceed that of the enlarger.

The same is true of other basic equipment; the cost of accessories can be an overriding factor in the purchase of an automatic printer or processor. To assess equipment needs realistically, consult with a photographic dealer who can help you list the equipment and who can recommend alternatives for added capacity, versatility, or convenience. Or visit labs in other cities and talk to the principals about their experiences.

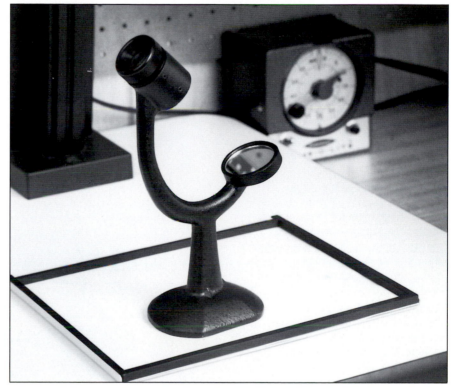

Small lab items, such as focusing aids, are often overlooked; review the equipment checklist to be sure you cover all lab needs.

DARKROOMS
Black-and-White Printing Rooms

Darkrooms for black-and-white printing vary in size from those that accommodate one operator who prints only occasionally to those large enough for a number of people to print and process throughout the day. For the individual, a room 6 x 8 feet (2 x 2.4 metres) is comfortable and large enough to hold equipment needed for ordinary printing.

In locations such as newspapers and camera clubs, where some people may need to process film while others make prints, a number of individual darkrooms may be preferable to one large printing room.

Quantity production of prints is best done in a larger room where several people can work together. The installation cost is less than that for a number of smaller rooms. Large darkrooms with multiple printing stations save construction costs, provide for better supervision, and permit group instruction.

Before designing facilities for high-volume black-and-white printing, consider continuous machine printing and processing. If this type of system is adaptable to your work, you can save money, space, time, and labor.

Safelights: A printing darkroom should be as well lighted as safety of the material in use permits. (See "Safety of Darkroom Illumination," page 35.) However, avoid situations in which direct rays from a safelight would fall on the enlarging easel. The direct light may obscure the projected image and make both dodging and exposure assessment more difficult. The safelight should go off during exposure of sensitized materials.

If you install several printing rooms, make sure that the lighting conditions are the same in each room. The number and positions of the safelights, as well as the reflectivity of the walls and ceiling, should be the same. Then printers can transfer from one printing room to another with a minimum of inconvenience.

Many printers habitually examine their prints under a white light placed over the fixing bath. This practice may be objectionable in a shared darkroom. Some operators fashion a long, cylindrical shade around the light and position it within a few inches of the surface of the fixer tray. Used with care, such a light will not disturb other printers.

Decision Diagram for Processing Method

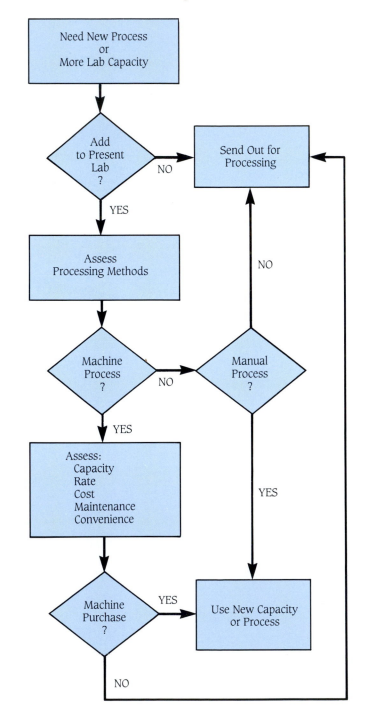

Hints: You can increase efficiency and reduce the cost of black-and-white printing by considering these points before installing printing rooms:

1. If you frequently make large quantities of prints or big enlargements, provide processing sinks and wash tanks that are as large as the space permits. Sinks that are too small restrict production and involve extra handling of prints. But don't install an over-sized sink just for an occasional large print. Use half-round trays or stack the trays.

2. Save time and reduce eyestrain by using an auto-focus enlarger if your work consists mainly of making a few prints each from a large number of negatives.

3. Use professionally designed dodging and burning tools to simplify complex printing jobs. EnlargerMate is a complete kit of these tools (for black-and-white as well as color) and is distributed by the Saunders Group.

4. Use a stabilization processor such as the KODAK EKTAMATIC Processor, Model 214-K. This type of processor provides quick proofs or prints for reproduction; you could use the KODAK DEKTOMATIC 65 Processor as well.

5. Provide suitable storage conditions for black-and-white papers. Paper stored at a high temperature and low humidity becomes hard to handle because of excessive curl—a condition that restricts production considerably.

6. For medium- to high-volume operations, consider a KODAK ROYALPRINT Processor, Model 417. This machine can process an 8 x 10-inch print on developer-incorporated water-resistant papers (such as KODAK POLYCONTRAST III RC Paper) dry-to-dry in 55 seconds.

Color Printing Rooms

A room approximately 8 x 10 feet (2.4 x 3 metres) is large enough for exposing and processing small quantities of color prints. If you use an 8 x 10-inch (20 x 25-centimetre) enlarger, you must allow some extra space to accommodate this bulky piece of equipment. Remember also that big enlargers require more headroom than smaller ones—10 feet (3 metres) is usually sufficient—although lowering the easel to the floor may reduce this requirement. The figure below shows a typical color-enlarger setup. For sophisticated enlargers, i.e., computer-driven color heads, additional space may be needed for support equipment, such as keyboards and power units.

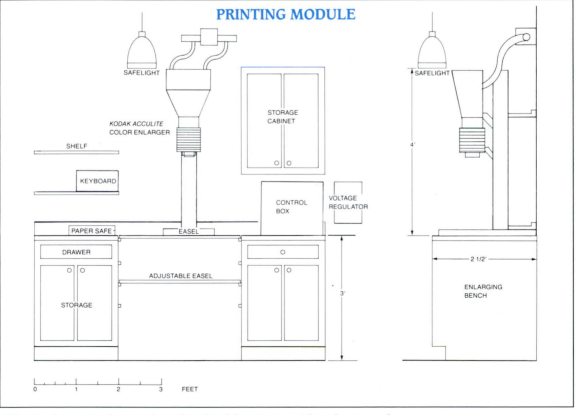

This enlarging station has ample cupboard and drawer space. The enlarger easel can be lowered for making big enlargements. Space large enough for a stabilization processor is provided at both sides of the enlarger.

Processing Rooms

A film-processing room for black-and-white work is usually about 6 x 8 feet (2 x 2.4 metres). The space required for color-film processing varies with process or tank design, number of process steps, and tank arrangement. One central wash tank can save space if the tank is the quick-emptying or quick-dump type.

On the other hand, a central wash tank limits production because only one rack of film can be processed at a time. If you process large amounts of color film, install a wash tank wherever a wash or rinse is required. In some processes, a pass-through permits a part of the process to be carried out in white light.

In a photolab where several people are doing color printing, individual printing darkrooms are necessary. A variety of processing options are available: trays, drums, baskets, automatic drums and roller-transport processors. Many labs use a centrally located basket processor to handle the output of a number of operators.

Most labs that process black-and-white and color film have a sink unit like that shown below. This sink module is usually placed in a completely darkened room with a small dry bench.

A center print-processing sink allows access from both sides. This type of sink is used mostly for black-and-white print processing, but can also be used for film processing and color print processing. The sink is usually surrounded by enlarging booths or rooms. This setup features a center-suspended shelf for chemical containers and other small items, a circular wash pass-through, a vertical tray-storage rack, and a thermostatic mixing valve. Four people can process black-and-white prints simultaneously and use a common stop bath and fixing bath. To accommodate more people, add about 18 inches (46 centimetres) per person to the length of the sink. The sink on page 20 is similar to the one described above in operation, except that it is for only one person and features a drain board.

Hints: You should handle most color materials in total darkness; the following suggestions apply to operations without safelighting:

1. Where several color printing rooms are grouped together, create a common dark hallway to the processor so that operators don't have to pass through a lighted hallway.

2. Number enlargers so that operators can make reprints on the same equipment for better consistency.

3. If you install telephones with indicator lights, be sure to inactivate the lights.

4. Use luminescent tape to mark door knobs, door jambs, counter edges, and other sharp surfaces or edges in the darkroom for worker orientation. The rims of trash cans could be marked with tape for easier use in the dark.

5. When you expose large-format color materials without vacuum equipment, hold the print material on a steel wall with magnets.

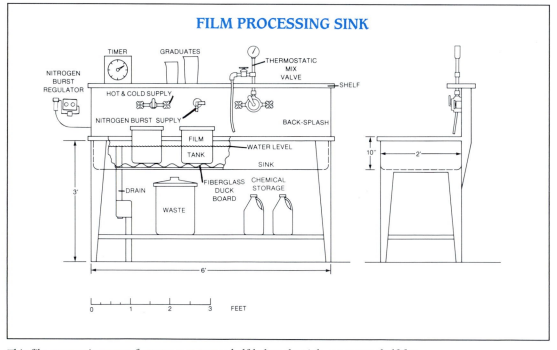

FILM PROCESSING SINK

This film-processing setup features a storage shelf below the sink, a narrow shelf for sundries above the sink, a back-splash, a tempered water supply with a thermostatic mixing valve, and a nitrogen-burst supply.

The darkroom should be large enough to accommodate the dark end of the process, a small bench, and a lighttight box to hold a loaded basket. To avoid too-frequent opening of the darkroom door, install a lighttight pass-through in the wall to receive boxes of exposed prints.

Install a light lock, formed by two doors, between the two rooms, or install a door-operated switch that turns the white light off automatically when the darkroom door is opened.

Equip all wet rooms with portable eye-wash units of saline solution.

Mount these units on a wall only a few steps from common work areas so that they are readily accessible to all employees.

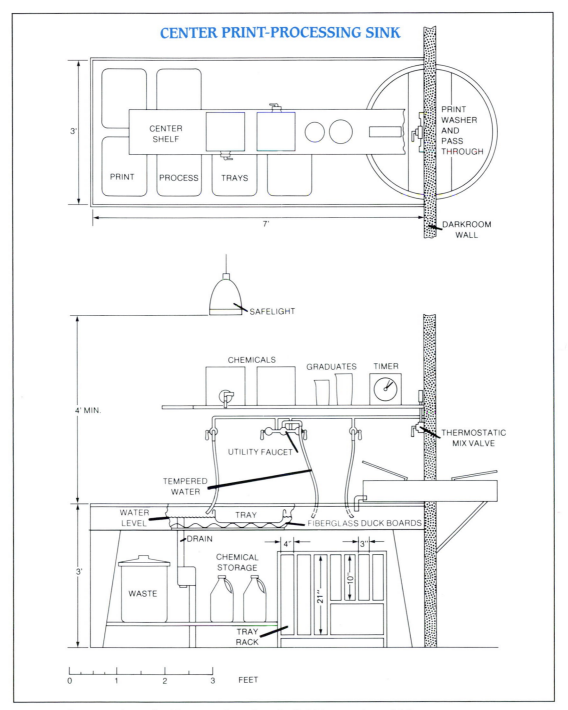

A center print-processing sink with a pass-through to the finishing area is useful for many larger darkroom applications.

PRINT-PROCESSING SINK

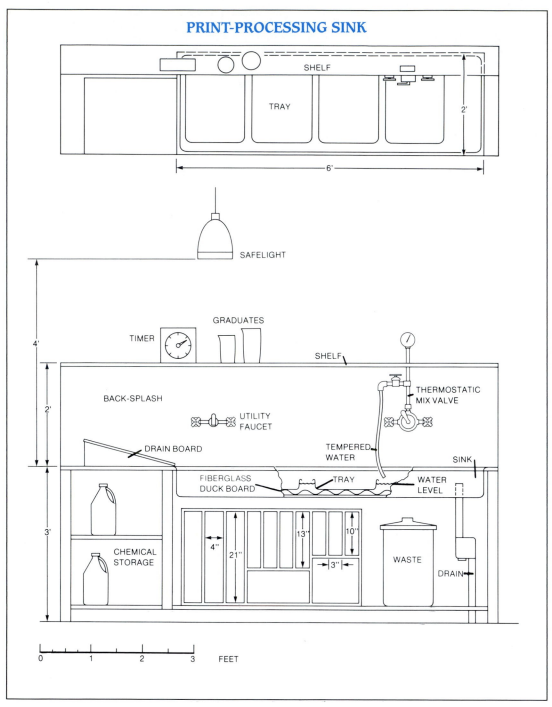

SHELF

TRAY

2'

6'

SAFELIGHT

GRADUATES

TIMER

SHELF

4'

THERMOSTATIC
MIX VALVE

BACK-SPLASH

UTILITY
FAUCET

2'

DRAIN BOARD

TEMPERED
WATER

SINK

FIBERGLASS
DUCK BOARD

TRAY

WATER
LEVEL

3'

13"

10"

4"

21"

3"

CHEMICAL
STORAGE

WASTE

DRAIN

0 1 2 3 FEET

This print-processing sink has enough work surface to handle 4 large trays plus a handy drain board. Below, there is ample room for storing containers of chemicals and extra trays.

Hints:

1. To avoid the possibility of fogging fast film, make the same test for complete darkness as described for film-loading rooms on page 24.

2. Install a locking device on the white-light switch to prevent the light from being switched on when film is being processed. See the list under "Safety and Convenience" on page 44.

3. Equip the film-processing sink with duckboards and a means of adjusting the temperature of processing solutions. In small-scale black-and-white work, an immersion heater and a cooling coil through which cold water can be passed will serve the purpose. For frequent processing, stand the tanks in a bath of tempered water to maintain the temperature. See "Water-Temperature Control," page 39.

 Consider installing one of the new microcomputer-based water-temperature controllers for more consistent control and rapid recovery from a sudden influx of cold or hot water.

4. To process large amounts of sheet film or to speed up processing, install an automatic black-and-white film processor, such as the KODAK VERSAMAT Film Processor, Model 11C-M. These machines save space and time by delivering negatives that are dry and ready for printing in 6 minutes.

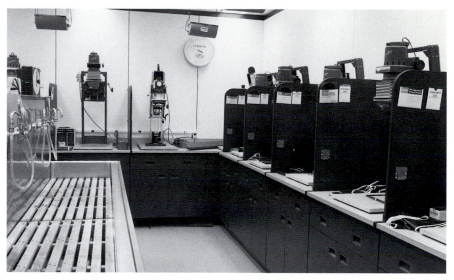

Half of a 16-station instructional darkroom is shown here. The center sink is divided, and the divider has multiple taps, all temperature-controlled by a single mixing valve.

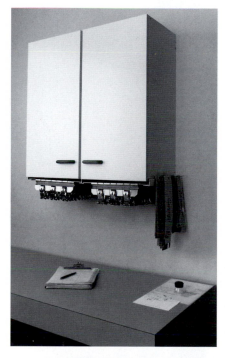

Place racks with film clips near the loading end of the processing machine. The area provides a neat and clean space for logging in film and tagging (see tags on right of cabinet) orders for special treatment, such as copyright-notice tagging.

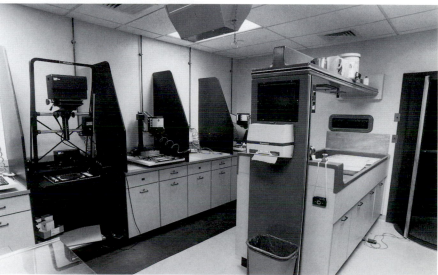

These enlarging stations use a common processing sink. Note the wall-mounted pass-through for prints. The Hartford Courant, *Hartford, CT.*

Large Display Prints: Big enlargements tax the facilities of the ordinary photolab. Obviously, larger processing and finishing rooms, as well as special equipment, are needed to produce large display prints regularly.

You can make a limited number of black-and-white prints—up to 30 x 40 inches (75 x 100 centimetres)—in a medium-size printing room. Use half-round trays as a convenient way to process a few prints of this size. Roll and reroll the paper through the solutions until processing is complete. Or you can machine-process KODAK POLYCONTRAST III RC Paper and other resin-coated papers up to 17 inches (43.2 centimetres) wide in the KODAK ROYALPRINT Processor, Model 417.

If you make color prints on KODAK DURAFLEX® RA Print Material, you can process them in a roller-transport processor with KODAK EKTACOLOR RA Chemicals for Process RA-4. Your processor must be capable of handling the 9-mil polyester base of the material.

KODAK DURATRANS® RA Display Material and KODAK DURACLEAR™ RA Display Material are designed for producing large color transparencies. You can also process these materials in roller-transport processors using EKTACOLOR RA Chemicals for Process RA-4. The processing equipment must be capable of handling their 7-mil base. Refer to KODAK Publication E-143, *KODAK Display and Print Materials for Process RA-4.*

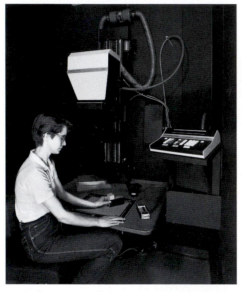

Typical operation of the KODAK ACCULITE Color Enlarger with a pedestal-mounted control unit.

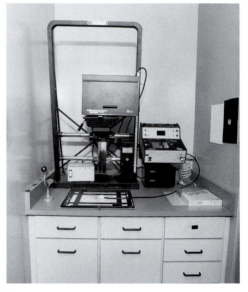

Color enlarging station in a corner niche at The Hartford Courant, Hartford, CT.

Typical installation of a large print processor with wall-mounted temperature-control and filtration units.

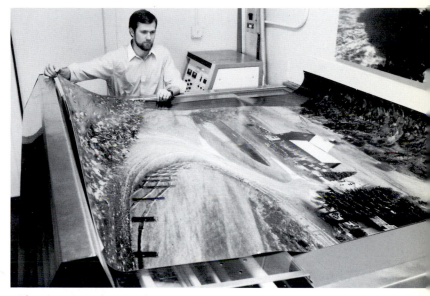

Wide print exiting from a color processor at ABAR Color Labs of NE, Inc., Providence, RI.

A print just processed in the KODAK ROYALPRINT Processor, Model 417. ABAR Color Labs of NE, Inc., Providence, R.I.

Chemical-mixing area and the dry end of a print processor. The Hartford Courant, *Hartford, CT.*

Light table in the center of a room with a color negative film processor. The Hartford Courant, *Hartford, CT.*

Film-Loading Rooms

These rooms can be as small as 4 x 5 feet (1.2 x 1.5 metres), and should be situated close to the camera room or studio. Absolute darkness, cleanliness, and exclusion of materials that generate static charges, such as synthetic fabrics, are the main requirements. Do not wear clothing made from synthetic fabrics when you are handling film. Maintain the relative humidity above 45 percent.

A space that appears completely dark to unadapted eyes may be unsafe for handling film. The best way to check for light leaks is to close the door and remain in the darkened room for about 10 minutes. When your eyes are dark-adapted, you will be able to see any light leaks. Ventilation openings and cracks above and below the door can admit light. Use strips of polyurethane foam or a similar material to caulk the door; mask over the openings of air ducts and fan openings with louvered boxes.

Cleanliness is important in a film-loading room. A dust-free atmosphere can avoid time-consuming spotting of both negatives and prints. Lintless lab coats are very helpful. Avoid plastic-laminated bench tops—polished wood is more suitable.

If dust is a problem or if your work is critical, consider installing a laminar-flow workbench or air-filter unit. If you decide to use such a unit, allow extra space for the filter unit at one end of the bench. Another idea is to pipe in compressed air from a central tank fed by an air compressor to blow dust from film holders just before loading them.

LIGHT ROOMS
Finishing Areas

Print Finishing: As a general rule, the print-finishing room should be about the same size as the total area of *all* the darkrooms it serves. A light trap is the best means of access to the finishing room from the processing area. A pass-through in the wall adjacent to the washing sinks provides print transfer from the darkroom without wetting the floor. An alternate design is a wash pass-through system where the wash unit starts within the darkroom. Most print drying occurs in the processing machines; dry prints leave the machine and are placed in bins that are accessible from the finishing room.

If prints are not dried in the processing machine, set up a table, bench, or sink near the dryer for conditioning or squeegeeing prints. Drum dryers work well for most manually processed prints. Dryers can be either single- or double-belt in design, allowing for ferrotyping or matt drying of prints made on fiber-based papers. Air-dry resin-coated (RC) papers, or use a dryer intended specifically for RC papers. Another type of dryer can handle resin-coated (RC) papers. Transparencies or negatives are usually dried in cabinets equipped with heaters, blowers, and filters. Some makes of cabinets have refrigeration-type dehumidifiers to improve drying efficiency.

To expedite sorting of prints into orders or batches, place a large sorting table next to the dryers. A print straightener near the sorting table can straighten fiber-based prints with excessive curl. Provide movable tables and benches in the finishing area to accommodate changes in workflow. A central work area can serve as a passageway and provide space for open storage or expansion.

The operations in print finishing should follow one another in logical sequence, and each work station must be able to handle the output from the preceding operations. In large-scale production, hindrances to the workflow usually occur at one of the finishing operations. You should be sure that there is sufficient washing and drying capacity to handle the maximum output of prints from the darkrooms. If service time is short, the breakdown of a drying machine could cause a serious delay. If possible, install standby equipment to take over in case of a breakdown.

Print Viewing: Set aside a place in the finishing room to examine prints for contrast, density, and color balance. The light used for viewing should have the same intensity and quality as the light in which the prints will be viewed or displayed. For example, portraits are usually displayed in the subdued illumination of a living room. On the other hand, exhibition prints are usually viewed under much more intense light—80 to 100 footcandles (860 to 1076 lux) is common.

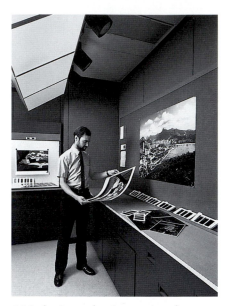

Critical print evaluation requires the appropriate illumination in the quality-control area.

Examine color prints under illumination of at least 50 footcandles (538 lux). A good average viewing condition is a light source with a color temperature of 4000 ±1000 K and a Color Rendering Index (CRI) of 85 to 100. Fluorescent tubes (in fixtures) such as Deluxe Cool White tubes made by several manufacturers meet these conditions. You can also use warmer tubes such as the Phillips 5000 K Ultralume, or a mixture of incandescent and fluorescent lamps. For each pair of 40-watt Deluxe Cool White tubes, use a 75-watt frosted tungsten bulb.

Paint the walls in the viewing area a neutral gray. Reflection of light from colored walls can affect the apparent image tone of black-and-white prints and the color balance of color prints.

Slide Mounting: Mounting usually requires only a small space in the finishing room. Provide space for slide mounts and other packaging materials nearby.

Transparency Viewing: For critical evaluation of transparencies, use a transparency illuminator that meets ANSI Standard PH2.30-1985, *Viewing Conditions—Photographic Prints, Transparencies, and Photomechanical Reproductions.* Many commercially produced illuminators meet this standard. However, many labs build their own illuminators, especially if the nature of their work does not require meeting these exact specifications and the transparencies are quite large.

See KODAK Publication No. E-84, *Backlit Displays with KODAK*

Materials, for details on constructing illuminators. For best results, use Cool White Deluxe fluorescent lamps.

Toning: Treat black-and-white prints with gold and selenium toners in a special sink in the finishing room. Because of the odor given off by sulfide toners, such as polysulfide and sepia, use these toners in a remote area. When you must tone large quantities of prints with a sulfide toner, install a ventilation hood and extraction fan above the sink. The fumes of hydrogen sulfide given off by these toners are unpleasant, can be harmful to the operator, and can fog unexposed film or paper.

Copying: Most labs make copy negatives. If yours does copying regularly, install a copying room with a film-

processing room adjacent to it. The size of the copying area depends on the maximum size of the original to be photographed. For fast copying of originals up to about 16 x 20 inches (40 x 50 centimetres), a vertical setup is more convenient to operate and takes less space than a horizontal setup.

Locate slide-making and related work—such as making duplicate color transparencies, internegatives, and black-and-white negatives from color transparencies or color negatives—in the copying room. To handle slide-duplicating economically, install a compact, illuminated slide copier that accepts a single-lens reflex camera with a macro lens.

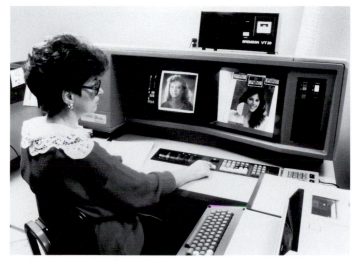

Evaluation of negatives in a video color analyzer at Custom Color Corporation in Kansas City, MO.

Large transparencies being evaluated at Sentry Color Labs Ltd. in Rochester, NY.

Quality control through KODAK TECHNET Service at Custom Color Corporation in Kansas City, MO.

Retouching/Spotting: A layout for a complete two-person operation is illustrated on page 54. The area is about 18 x 12 feet (5.5 x 3.7 metres). The space is divided into two sections; one has subdued lighting for negative retouching, the other normal lighting for print spotting. Retouching areas for one person require only half this area or less. For more information on retouching, see KODAK Publication No. E-97, *Photographic Retouching.*

Lacquering: A spray booth or lacquering area does not take up a great deal of space. It should, however, be separated from other operations and have a fire-protected exhaust hood and a spark-proof fan. Lacquers and thinners are very volatile and are dangerous if you inhale them. Proper dust-free ventilation is vital. Relative humidity should be 50 percent or lower.

Laminating/Framing: Laminating is a process of rolling a thin layer of dry plastic sheeting that contains a thermosetting, pressure-sensitive, or contact adhesive onto a photographic material. Lamination protects prints from dirt, fungus, bacteria, moisture, and air pollution. The specialized equipment required for this operation is shown on the right.

The final steps in the production process are mounting and framing the photographs. Provide adequate space to store materials, such as mounting boards, framing kits, and glass, as well as space for assembly and packaging.

Feed end of a laminator at ABAR Color Labs of NE, Inc., Providence, RI.

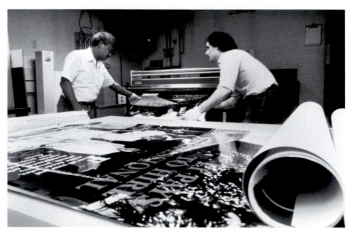

Large color print finishing in the Mounting-Laminating Department at Custom Color Corporation in Kansas City, MO.

Cutting continuous-roll prints at Custom Color Corporation in Kansas City, MO.

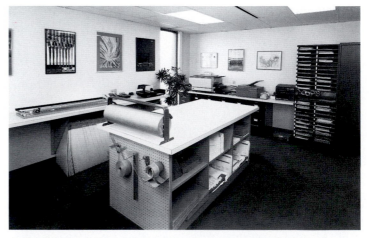

In the shipping room, air-express envelopes, packing paper, tape, and a postage meter help to speed jobs to the customer. The upright cabinet to the right stores printed samples of previous jobs for review by prospective clients. James Scherzi Photography Inc., Syracuse, NY.

Chemical-Mixing Rooms

In a small studio or a small photographic department, you can prepare chemicals for a day's work in a conveniently located sink. In black-and-white processing, you can dispense with routine chemical mixing by using liquid concentrates, such as KODAK T-MAX Developer for film and KODAK EKTAFLO Developers for print processing. You simply mix these concentrates with water to make working-strength solutions.

A large finishing plant that processes color and black-and-white materials requires a separate chemical-mixing room. The size of the room is determined by the volume of solutions to be mixed and the number of processes. A well-ventilated space of about 8 x 10 feet (2.4 x 3 metres) is usually sufficient. If you use large volumes of solutions continuously, it is more economical to mix them in large batches. Then you would have to provide more space for large storage tanks.

The ideal place for a chemical-mixing room is on the floor above the processing area. You can gravity-feed the solutions from the storage tanks to the processor or replenisher tanks. This method permits short pipelines that are easy to keep clean. Another common alternative is to have the mix area on the same floor as the processing area with storage tanks on the floor above or in a loft. This setup requires a special pump-up, quick-release valve system.

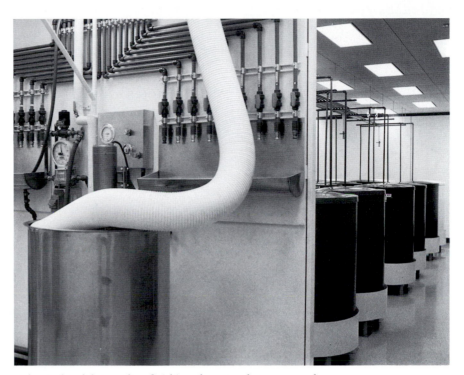

A large photolab or a photofinishing plant may have a central chemical-mixing station and piping to transfer chemicals to storage tanks. Such a system can be constructed on a smaller scale for laboratories with lower chemical consumption and fewer processes.

Floating lids used on replenisher storage tanks reduce oxidation and contamination from dirt and other chemicals.

When you store chemical solutions on an upper floor, make sure the floor can support their weight. The average weight of a gallon of photographic chemicals is 9¼ pounds (1.1 kilograms per litre). Include this figure with the weight of the tanks as well as any dry chemicals if you consider storing chemicals on an upper floor.

If the chemical-mixing room must be on the same level as the processing rooms, place the storage tanks on a platform about 7 feet (2.1 metres) high; if this isn't possible, you may have difficulty in getting enough head pressure to gravity-feed the solutions.

Design the mix area so that the floor drain is at the lowest part of the room, usually the center. This drain should go to the municipal sewer, not a storm sewer or a septic tank. It is also important to have a curb around the perimeter of the room so that spills are contained. In large installations, a safety shower should be a standard part of the plan. Another safety item is an eye bath. In mixing rooms, locate a 15-minute flowing eye bath in the immediate area, not beyond a door or around a corner. Finally, isolate chemical mixing from areas where chemical dust would be harmful to personnel and photographic materials.

An air-exhaust opening at the rear of this sink provides air flow across the sink to remove fumes immediately.

Ventilation: Provide at least 6 to 10 changes of room air per hour in all mixing areas. Also, use split tank covers with local exhaust attached to the stationary portion on mix tanks to supplement the general room ventilation. Local exhaust should provide a minimum capture velocity of 100 fpm (30.5 metres per minute) at weighing and dispensing locations. Minimize evaporation by covering the storage tanks; floating covers are also effective.

Dry-Chemical Storage: Store powdered chemicals in a cool, dry place. To avoid running out of a particular chemical due to a sudden demand, keep an adequate stock on hand. The absence of even one material could paralyze part of your processing operation.

For a small lab, store a reserve stock of chemicals in a large cabinet. A large processing plant must carry a big stock of chemicals; this requires a space half the size of the mixing room. To avoid unnecessary handling of heavy packages, the chemical-storage room should adjoin the mixing room.

Metal shelves or bins fixed to the walls of the storeroom provide a suitable place for storage. They also prevent stacking too many heavy packages on top of one another, which can result in the lower containers being crushed and the contents spilled.

Avoid storing packages or bags of dry chemicals in direct contact with the floor. Also, some floors, particularly concrete on or below grade, are

damp, and there is usually a risk of water damage due to overflowing sinks or similar accidents. If you store dry chemicals at floor level, construct a wooden platform about 4 inches (10 centimetres) high or use a standard pallet to store packages.

Sensitized-Goods Storage Rooms

Adverse storage conditions deteriorate both the physical and the photographic properties of sensitized materials. Always store unexposed color films, papers, and display/print materials at 55°F (13°C) or lower. Store unexposed black-and-white film and paper at 75°F (24°C) or lower. Protect all unexposed sensitized materials from exposure to radioactive materials and x-ray equipment.

Refrigeration at about 55°F (13°C) or lower, coupled with relative humidities between 40 and 50 percent provides ideal storage conditions if the materials are to be used within one year. Changes in the photographic characteristics of sensitized materials can be almost completely arrested over much longer periods by storage in a freezer at temperatures between 0 and −10°F (−18 and −23°C).

You can store small amounts of color materials and black-and-white films in the original sealed package in an ordinary refrigerator. Store black-and-white paper in a cool place with a relative humidity below 50 percent. If the humidity exceeds 50 percent, install a dehumidifier.

Store large supplies of paper and film in an air-conditioned room. You can purchase a room with temperature and relative humidity adjustments as a complete unit; 8 x 8 feet (2.4 x 2.4 metres) is a suitable size for all but the largest labs.

Keep exposed films and process-control strips in a freezer. Usually, the freezer compartment of a household refrigerator is large enough. Store these materials in airtight packages; otherwise, the high relative humidity in the freezer may damage them. Observe the appropriate warm-up times for photographic materials; don't open sealed packages until the material reaches room temperature. Otherwise, condensation will cause problems.

Customer-Service Areas

Whether your lab is independent or is part of a larger business, customer service is vital to its success. First impressions do count. A reception area may present the public image of a portrait or commercial photographer or it may be the mail delivery and dispatch station for a large photofinisher. But all areas visited by customers should be efficient and visually attractive.

Wall displays, such as giant backlit transparencies or collections of fine photographs, are silent salesmen. A separate slide-viewing room with an illuminator table and comfortable chairs will foster on-the-spot orders for reprints or dupe transparencies.

Finally, don't forget a night film drop. Install it in or near the front door. Make sure your service hours are printed on it so that customers can easily read them at night. A night drop should be weatherproof and tamperproof. This kind of access will allow customers the convenience of dropping film off at any time.

For a look at customer-service areas, see pages 4 and 6.

Business Areas

Almost any business operation requires offices to accommodate the buying and selling, accounting, and filing functions. Office space is needed for key lab personnel. An architect can advise you on the appropriate area for various business functions. Also consider installing computer systems to handle accounting functions and job tracking within the lab. Another tool, important to many businesses, is the FAX machine. Allow space for this device, perhaps near the copying machine.

A conference room is an integral part of many labs. Such a room needs ample seating space with adequate lighting and viewing capabilities. Other additions would be a telephone, a TV/VCR, dissolve projectors, a projection screen, and an intercom. A conference room can serve as a temporary work space for a client during a shoot or processing.

Many labs include a studio with lighting units, either portable or suspended from ceiling tracks. The height of many studios is 15 feet (4.5 metres) or more. Studios need backgrounds, props, diffusers, and other specialized equipment. While these areas do not form part of the lab itself, they do need services and utilities that you must take into account in planning the total operation. For instance, the studio will need enough electrical power to run banks of lights. The total heating and cooling load for a lab will be heavily influenced by the volume of a large studio filled with heat-producing lamps used on an intermittent basis.

Finally, the design of a break or lunchroom is important for most labs. One such area is shown on page 4. You may also want to provide a separate smoking area. Check with your municipality; you may have to observe special regulations.

Support Areas

The most common support area is the maintenance or utility room. A storage space for cleaning supplies and small maintenance items, such as replacement water filters, is essential to the smooth operation of the photolab. Many businesses use a spare room as a woodworking/metal shop with a limited number of power tools for making minor items to support the lab. Such an area can save downtime by providing quick, on-site maintenance.

Some studios set up areas for tools and small support items, such as clamps and gaffer's tape, for ready access during shoots. This area need not be a separate room; it can be located in a space adjacent to the studio or in a wide hallway.

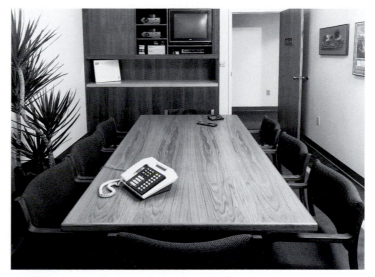

Conference room of James Scherzi Photography Inc., Syracuse, NY. It includes a telephone, dissolve slide projectors, a VCR with a monitor, and a slide illuminator. This space is often used by clients during shoots at the studio.

Technical support area just off the studio floor at James Scherzi Photography Inc., Syracuse, NY. Most of the items on the pegboard are "outlined" with a marking pen. This establishes a space for the item to make it easier to return it to its unique spot and keep the area neat and organized.

Section III Detailed Planning

HEALTH AND SAFETY

In setting up your photolab, you must consider the safety requirements for protecting your employees, plant, and equipment. Protecting personal health and safety is good business practice and good human relations as well as a requirement of Federal law. You must satisfy your own insurance underwriters, and you must comply with Federal, state, and local codes. Find out what your obligations are under the Occupational Safety and Health Act of 1970 if you are in the United States, or check for similar laws in other countries.

Planning a safe work area goes hand-in-hand with the design for efficient workflow and best space utilization. Nothing should override health and safety. Review all the design criteria and construction details noted in this book for specific ideas on increasing safety and avoiding hazards.

One requirement for personnel health is compliance with sanitary codes. You must label taps carrying water that is unfit for drinking. Lunchrooms or lounges should be remote from chemical-mixing rooms, spray booths, and darkrooms. Confine smoking to designated areas away from darkrooms and finishing rooms. Ventilate smoking rooms directly to the outside.

Such general construction details as hallways, doors, windows, and exits are usually specified in local building codes. Codes also cover the proper and safe installation of plumbing and electrical wiring. Because electrical equipment and plumbing must be used in close proximity, and frequently in the dark, consider using ground-fault circuit interrupters in high-hazard areas. Check the local electrical code for such requirements.

Fire-protection and fire-suppression methods may be detailed in a code or they may be treated only generally.

Safety equipment such as fire extinguishers, eye-wash units, and first-aid kits should be readily accessible in the laboratory.

The insurance underwriter will usually have complete guidelines for fire protection. Plan for alarm systems, smoke alarms, appropriately placed fire extinguishers, and sprinklers or automatic chemical extinguishers. Darkrooms pose a particular challenge to designers and contractors, because the people who will use them must work in subdued light or total darkness. In addition to observing the notes in other sections on the treatment of walls, floors, and work surfaces, you should eliminate sharp corners on workbenches, install cabinets with sliding doors, and provide recesses for waste cans, unobstructed safety exits opening outward, and locks that can be defeated from the outside in case of an emergency.

Emergency Planning

Part of the detailed planning for the photolab is establishing a written emergency plan. Training of personnel is an ongoing process; use the guidelines in this book for basic orientation of employees. Some of the items you may want to include are listed below:

Personnel:

1. Post emergency medical/ambulance phone numbers.
2. Provide portable eye-wash units in all wet darkrooms.
3. Have a 15-minute eye-wash unit in the chemical-mixing area.
4. Provide appropriate protection: rubber gloves, safety glasses, aprons and boots.
5. Have a first-aid kit readily available.

Fire:

1. Provide safe exit routes and emergency exits for darkrooms.
2. Post the appropriate emergency phone number on all telephones to call the fire department.
3. Have suitable fire extinguishers in strategic locations.
4. Test the effectiveness of fire-protection systems frequently.

Chemical Spills:

1. Provide an adequate drain in the chemical-mixing area.
2. Install a curbed edge in the mix area for containment.
3. Have pumps and other cleanup equipment available.
4. Provide appropriate clothing for cleanup personnel.

Kodak maintains a 24-hour, 7-day-per-week telephone number for health, safety, and environmental emergency information on Kodak products. The telephone number is

(716) 722-5151

If you have questions about planning for health emergencies, leaks, or spills, read the chemical labels and Material Safety Data Sheets (MSDS) for specific chemicals.

DOORS

Darkroom Entrances

Small darkrooms, such as those used for film processing, film loading, and small-scale printing, usually have a single lighttight door. Provide doors of this kind with a small lock or bolt that can be forced easily in an emergency.

Doors for large darkrooms can be either light locks or light traps. First-generation original film images, which require the most security, are processed in rooms protected by light locks. Second-generation images produced from negatives or transparencies do not require as much security. Light traps may provide adequate protection for handling second-generation images.

Light Locks: This type of entrance generally serves larger film-processing rooms and color printing rooms, where you must protect light-sensitive material but also provide free access. A light lock consists of a small hall with two doors; one of the doors opens into the darkroom and the other opens to the outside.

Interlocking devices, either electrical or mechanical, prevent accidental opening of both doors at the same time. However, the interlocking system must incorporate a safety release so that you can open both doors in an emergency, or move bulky objects in or out of the darkroom. In processing rooms where several people work, install an emergency door that is easily opened from the inside. This door also permits movement of large pieces of equipment or supplies.

To relieve changes in air pressure caused by opening and closing the doors and to provide ventilation, install a lightproof vent in the doors or in a wall of the light lock. Hinged doors, sliding doors, or a combination of the two can also serve as a light lock. Illuminate the dark interior of the light lock with a safelight equipped with the appropriate safelight filter.

Minimum dimensions for a light lock depend on the size of the doors. The smallest useful door size is 80 inches (2 metres) high and 24 to 30 inches (60 to 75 centimetres) wide. Allow at least 3 feet (0.9 metre) for the space between doors. If space is at a premium, you can use sliding doors instead of hinged ones.

Another form of light lock is the rotary door. Rotary doors are designed to enter two, three, or four areas. Note that as the number of areas served (rooms accessed) goes up, so does the diameter of the unit. This can be a critical planning consideration if space is tight. Many labs fit these doors with a hinge on one side and a magnetic refrigerator-type gasket on the other. This allows the rotary door to be swung out from its opening for equipment movement or cleaning.

Finally, one design even has a red-filter material built into the door at eye level so that the operator can see out from the darkroom into the adjoining light room.

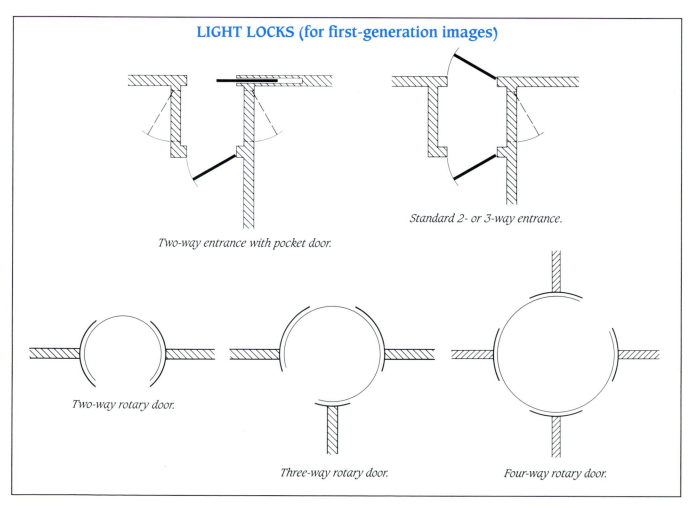

LIGHT LOCKS (for first-generation images)

Two-way entrance with pocket door.

Standard 2- or 3-way entrance.

Two-way rotary door.

Three-way rotary door.

Four-way rotary door.

Light Traps: This type of darkroom entrance may be suitable only for black-and-white printing rooms, because total darkness is difficult to achieve. However, it does permit easy passage from room to room and allows free air circulation. An efficient light trap requires at least twice as much space as a light lock.

The safety of a light trap depends on reducing reflection of white light to a minimum. Paint the interior walls of the light trap with matte-black paint. Avoid placing this kind of darkroom entrance (all drawings at right) opposite a window or light-colored wall. Provide subdued illumination in the immediate vicinity of the light trap. To help guide people through the darkened entrance, paint white arrows at eye level on the interior walls.

It is usually impossible to pass bulky articles through a light trap; to overcome this difficulty, place a lighttight door in the center baffle, as shown in drawing C. Or you can situate an emergency exit in another part of the darkroom and use it to move goods and large pieces of equipment in and out of the room.

To permit easy access, make the light-trap entrance at least 2 feet (60 centimetres) wide. To reduce the amount of light entering from the outside, limit the entrance height to 80 inches (2 metres).

If space is limited, a light trap may not fit. In this case, curtains (a modified type of light trap) probably provide the best means of blacking out darkroom entrances. A triangular curtained light trap is shown in drawing D. However, this alternative is suitable only for black-and-white printing rooms or rooms where you won't be handling very light-sensitive material. If the illumination outside the darkroom is strong, two pairs of curtains that are deeply overlapped

and placed about 18 inches (45 centimetres) apart will make a fairly good light trap. Curtains should be made from a strong opaque fabric that will withstand considerable abuse. Install the curtains as close to the floor as possible, and weight the bottom edges with heavy chain to keep them in place.

Where several darkrooms give access to a passage or corridor, you can

install light traps at both ends of the passage, and then use a single pair of curtains to cover each darkroom entrance. Illuminate the passage with a suitable safelight. This arrangement is very convenient because it allows free access to the darkrooms without the use of solid doors.

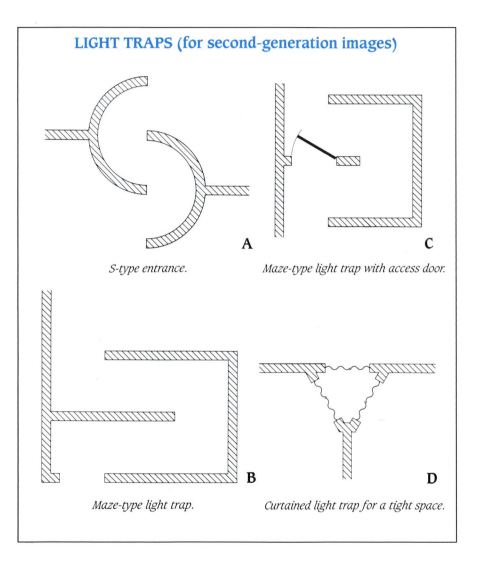

LIGHT TRAPS (for second-generation images)

S-type entrance. **A**

Maze-type light trap with access door. **C**

Maze-type light trap. **B**

Curtained light trap for a tight space. **D**

FINISHES

Ceilings

To obtain the greatest reflection from overhead safelights, paint darkroom ceilings with a smooth white paint. A ceiling of average height is suitable for most processing rooms. However, if you intend to install an 8 x 10-inch (20 x 25-centimetres) vertical enlarger, remember that most machines of this type require at least 10 feet (3 metres) of clearance.

Suspended ceilings are very common in most buildings, but keep in mind that they are not lighttight. Be sure to mask off all possible sources of light before installing a suspended ceiling. You must also consider the effect of falling particles. In small rooms, when doors are closed quickly or slammed, ceiling panels may pop. Over the long term, this could cause dirt problems, especially in film-loading rooms.

Darkroom Walls

The fabrication of walls need not be any different from that of normal walls. However, if you are using Sheetrock wall material, you might consider not taping the seams. Instead, cover the seams with a batten-type board fastened with screws. This allows for easy removal of panels for room rearrangement or equipment movement.

Darkroom walls are rarely painted black. When you place an enlarger against a wall, you may need to paint the wall behind the enlarger black to prevent the light from the projected beam from reflecting back to the sensitized material during exposure. Use a light-colored paint for the rest of the wall. Cream or light beige is easier to maintain than white paint.

Protect parts of the darkroom wall that are close to the processing sinks from chemical splashes or dampness by covering them with a water-resistant coating. Ceramic tile can be used for this purpose, but excellent water-impervious paints are much cheaper. Paint for this purpose should be chemical-resistant, stain-resistant,

and waterproof. Several plastic-based materials meet these requirements. Epoxy paint provides an excellent chemical-resistant coating; however, be sure to use an amine-cured, high-solids epoxy material for darkrooms.

When you apply the protective coating, cover the entire surface so that not even the smallest area is left unprotected. Have this work done before the sinks and other processing equipment are installed; otherwise, parts of the wall may be left uncoated. Be sure to remove sensitized materials from the area before you apply paints, lacquers, and varnishes, because fumes from some of these materials will fog photographic emulsions. Wait a minimum of 36 hours before handling sensitized materials in the darkroom.

Finishing-Room Walls

Decorate the finishing room walls tastefully in pastel colors. A two-tone effect relieves monotony. However, in an area where you examine or evaluate color prints, use a neutral gray.

Protect the parts of a wall next to washing sinks and pass-through boxes from splashes by applying a protective coating similar to that used for the darkroom walls. Semi-gloss paint will simplify cleaning.

Floors

The ideal floor for a processing room is waterproof and resistant to chemicals and stains, does not become slippery when wet (a condition especially dangerous in a darkroom), is resilient for underfoot comfort, and requires minimal care to keep it in good condition. Obviously, no one kind of floor meets all these requirements, so you must select the material that best suits your conditions.

Consider the following points when choosing material for a processing-room floor:

1. The amount of traffic that the floor must bear and the amount of chemical and water spillage that the floor will be subjected to.

2. The cost of materials, installation, and maintenance. The cost of flooring material is usually secondary to installation and maintenance costs, but the larger the floor, the more important the cost of the material. The cost of installation varies considerably with the type of covering and with the amount of preparation required by the subfloor. Good housekeeping requires that any floor be kept in good condition; this involves considerable labor with a large floor that is difficult to keep clean.

3. The construction and condition of the subfloor. These factors may restrict your choice of flooring for a particular area. With a suitable underlay, you can install practically any floor covering over structurally sound wooden subfloors. Concrete subfloors, both on-grade and below-grade, can be excessively damp. In these cases, you may not be able to install resilient flooring, such as asphalt tile. Your flooring contractor can make humidity and adhesion tests to determine this point.

If the subfloor is above-grade (a suspended floor), you must be able to install the floor covering so that the whole area is waterproof. Otherwise, chemicals and water may damage the base of the walls, the ceilings below, and the contents of lower rooms.

4. Adaptability of flooring materials. If possible, install floors that are adaptable to other uses, such as those that are easily extended if walls or partitions are moved. For example, it would be expensive to take up or extend a ceramic tile floor if an alteration became necessary.

The following descriptions of common flooring materials and their suitability for use in various situations can help you to decide which material is best for you. In case of doubt, obtain technical advice from the leading manufacturers of resilient flooring or consult with your architect.

Burned Clay: Ceramic tile and quarry tile are burned-clay materials used in chemical-mixing and similar rooms. Install either material over a concrete subfloor at any level or over a sound wooden floor with a suitable underlay. Use an epoxy-mortar setting bed and epoxy grouting material.

These chemical-resistant and water-proof materials keep the floor impervious to chemical solutions and water for a long time. Form a curb at the perimeter of the floor to protect the base of the walls, and provide a central drain to facilitate hosing down the area.

Seamless: A recent addition to the range of impervious flooring materials is thermosetting epoxy. You can use epoxy flooring in the same situations as ceramic tile, and it is often less expensive. Because it is seamless, it tends to be dust-free and can be molded to form a raised curb at the perimeter of the floor. In wet areas, use an aggregate to provide a non-slip surface.

Resilient: This general description applies to asphalt tile, vinyl tile, sheet linoleum, and rubber tile. Although all these floor coverings are appropriate for particular uses, asphalt tile is the most successful for processing rooms. Even the best resilient tile loosens, however, if the floor is constantly wet. Lay a waterproof membrane over the subfloor to prevent structural damage to the building by chemical seepage. Also install a waterproof cove base at the perimeter of the floor to protect the base of the walls.

Problems with resilient flooring occur more often because of incorrect installation than because of shortcomings in the material itself. Be sure to follow the manufacturer's installation procedures exactly.

Asphalt Tile: This material, used successfully in processing rooms for a number of years, is one of the cheapest floor coverings. With the recommended underlay, you can install asphalt tile over wooden floors or over concrete subfloors (at all grades if the concrete is reasonably dry). Do not install asphalt tile in places that are subject to sudden reductions in

Non-slip ceramic tile covers the floor of this chemical-mixing room. A raised curb will contain chemical spills.

temperature; it will break. For example, do not install asphalt tile just inside a door that is opened frequently in severe winter weather.

Rubber Tile: This is one of the best floors for underfoot comfort; however, do not use it in wet locations, because the surface will become slippery.

Vinyl Tile: Available in many attractive designs and colors, this material is suitable for reception rooms or show-rooms. There are different grades of vinyl tile; the cheaper grades are not suitable for heavy use because the surface is easily scratched. Vinyl tile is quite expensive; for general applications, it provides no advantages over asphalt tile.

Vinyl Sheet: Sheet flooring works well in clean-room installations, where control of dust is important. The joints in a tile floor tend to collect dust, but sheet material has only one seam in an average-size floor. Also, you can turn up sheet material to form a cove at the perimeter of the floor. This eliminates dust-collecting corners and angles. A recently developed technique for installing sheet-vinyl flooring employs an adhesive that sets up chemically to provide waterproof and chemical-resistant seams at points where seepage might occur.

SPECIALTIES
Louvers and Vents

Air-circulation fixtures need to be light-tight as well as efficient. Units designed specifically for photographic use are available; use these units in critical locations, e.g., where a dark-room is adjacent to a light room. Other areas may not need specially designed units, and simple light baffles can eliminate stray light.

Fire Extinguishers

The appropriate extinguisher is vital to keeping a simple emergency under control. Using the wrong type of extinguisher in a critical situation, such as an electrical fire, could be fatal. Be sure to locate appropriate extinguishers near electrical boxes. Train employees to use the different extinguishers in your lab. Above all, place a fire extinguisher in the lacquering area.

EQUIPMENT

Safelights

The term "safelighting" describes darkroom illumination that does not fog or cause any other visible change to a light-sensitive material under recommended conditions of handling and processing. The word "safe" is a relative term. Most sensitized materials will become fogged if you expose them to a safelight for an extended time. Since photographic materials vary widely in both speed and sensitivity to light of different colors, the color and intensity of safelighting will also vary to give maximum safe illumination for each type of material.

You can use a safelight in rooms used for printing color negatives on *some* color papers, print materials, and display materials. For example, you can use a safelight equipped with a KODAK 10 Safelight Filter (dark amber) for handling KODAK EKTACOLOR PLUS and Professional Papers, DURAFLEX Print Material, and DURATRANS Display Material. You must handle color films, color reversal papers, and panchromatic black-and-white films in total darkness.

In black-and-white printing rooms, you can provide a good level of general safelight illumination to help the operators. Avoid concentrated areas of light against a background of darkness because this tends to fatigue the eyes. Achieve good general safelight illumination by combining reflected light from a white ceiling with the more concentrated light from safelight lamps hanging over the work benches and sinks.

The KODAK Utility Safelight Lamp, Model D, provides good general illumination with the light directed toward the ceiling. Allow approximately 60 square feet (5.5 square metres) of ceiling for one lamp. For more concentrated illumination over benches and sinks, you can use the KODAK 2-Way Safelamp. Install this unit either on the wall or ceiling, 4 feet (1.2 metres) from the sensitized material; use a 15-watt bulb and the appropriate safelight filter. You can use a number of these lamps in a printing room, but place them at least 5 feet (1.5 metres) apart.

KODAK Safelight Lamps: Kodak makes several types of safelight lamps to suit various applications.

KODAK Darkroom Lamp (CAT No. 152 1178): This general-purpose safelight lamp can be screwed into standard lightbulb sockets. It provides illumination over sinks and benches. It accepts 5½-inch-diameter filters. This lamp uses either a 15- or 7½-watt bulb.

KODAK Adjustable Safelight Lamp, Model B (CAT No. 141 2212): Similar in design to the KODAK Darkroom Lamp, this safelight can be mounted on a wall or beneath a shelf with the bracket and screws provided. This lamp holds a 5½-inch circular filter and uses either a 15- or a 7½-watt bulb, and has a double-swivel shank.

KODAK 2-Way Safelamp (CAT No. 153 3660): This safelight lamp screws into a standard socket and swivels to provide either direct or indirect illumination. It uses a 3¼ x 4¾-inch filter and a 15- or 7½-watt bulb. If you want safelight illumination in two directions, replace the removable metal panel with a second filter.

KODAK Utility Safelight Lamp, Model D (CAT No. 141 2261): This lamp hangs on chains attached to the ceiling and can give either direct or indirect illumination. Use the appropriate filter and bulb specified in the table on page 36. A bracket (CAT No. 152 1194) is also available for mounting the lamp on a wall or bench.

If you handle materials that have special safelight requirements in your lab, you can change the safelight filters to suit the materials. Where general darkroom illumination comes from ceiling safelights, such as the KODAK Utility Safelight Lamp, Model D, changing filters may be a nuisance or even cause costly delays in production. In such a case, it may be better to have two sets of safelights wired to separate switches so that you can change from one illumination to another quickly and conveniently. Since it is easier to change the filters in safelights that are positioned for local illumination (over the developing sink, for example), you may decide you need only one safelight in these areas.

With a darkroom equipped this way, you can quickly change from a normal printing room to a panchromatic-paper printing room, or even to a film-processing room by the throw of a couple of switches or by changing filters in the safelight lamps that are at a convenient height.

Safety of Darkroom Illumination: Check the condition of your safelight filters at regular intervals. Throw away any that are cracked or damaged. Replace filters that have become faded due to situations where safelights have been left on for excessively long periods.

Use special precautions where there is a high level of safelight illumination, as in black-and-white printing rooms. Unsafe darkroom illumination can cause image-degrading fog. Small amounts of such fog go undetected under working conditions, because the white borders, or unexposed parts of the paper, may be less affected. Safe-light fog combines with the image exposure to produce higher density, more noticeable in the highlights. As a result, your prints may appear flat or muddy for no apparent reason.

Test your safelight conditions frequently according to the procedures in KODAK Publication No. K-4, *How Safe Is Your Safelight?*

Safelight Recommendations

KODAK FILTER	COLOR	FOR USE WITH KODAK MATERIAL	BULB WATTAGE (110 to 130 VOLTS)*	
			Direct Illumination (not closer than 1.2 m [4 ft])	Indirect Illumination†
NOTE: Refer to the carton or the instruction sheet for complete safelight recommendations.				
OA	Greenish yellow	Black-and-white contact and duplicating materials. Projection films.	15-watt	25-watt
OC	Light amber	Contact and enlarging papers, TRANSLITE Film.	15-watt	25-watt
1A	Light red	Slow orthochromatic materials. Orthochromatic KODALITH and KODAGRAPH Materials. High-resolution plates.	15-watt	25-watt
3†	Dark green	Some panchromatic materials.	15-watt	25-watt
10	Dark amber	PANALURE Paper.	7½-watt	15-watt
13§	Amber	PANALURE, PANALURE II RC, and PANALURE II Repro RC Papers.	15-watt	25-watt
		EKTACOLOR Papers, DURATRANS and DURACLEAR Display Materials, and DURAFLEX Print Materials.	Not Recommended‖	Not Recommended

CAUTION: Refer to individual product instruction sheets about time limitations on exposure to safelight illumination. This is particularly important with Safelight Filters No. 3, 10, and 13.

*With 200- to 250-volt supplies, you can substitute a 25-watt pearl lamp of European manufacture for a 15-watt frosted lamp.

†Data in this column refer only to the use of the KODAK Utility Safelight Lamp.

†See the film instructions for information on using a KODAK Safelight Filter No. 3 during processing of panchromatic films.

§The KODAK 13 Safelight Filter is generally preferable to the KODAK 10 Safelight Filter for use with products that are listed under both filters as it provides brighter illumination.

‖These products should be handled in total darkness. Using a safelight *will* affect your results. **If it is absolutely necessary** to use a safelight, its effect can be minimized by using a KODAK 13 Safelight Filter with a 7½-watt bulb at least 4 feet (1.2 metres) from the light-sensitive emulsion. Keep exposure to the safelight as short as possible.

Cabinets

Cabinet height is usually 36 to 40 inches (91 to 102 centimetres), with a working surface (counter) depth of 24 to 26 inches (61 to 66 centimetres). For the average enlarger, you need 36 to 48 inches (91 to 122 centimetres) of counter width. Prefabricated cabinets, with drawers or shelves, that fit under counters are readily available from a number of sources. These units come in widths from 15 to 36 inches (38 to 91 centimetres) in 3-inch (7.6-centimetre) increments.

You can vary the height of counters to accommodate workers taller than 6 feet (1.83 metres) or shorter than 5 feet 6 inches (1.76 metres). Cabinet height has a direct impact on productivity, so it is important to install cabinets and sinks of the right height. For the average-height person, the sink edge should be between 40 and 42 inches (102 and 107 centimetres) from the floor to allow maximun working comfort.

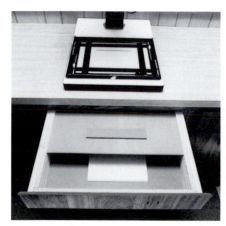

Cabinet with a built-in paper safe in a printing darkroom.

Hang wall cabinets so that their bottom surfaces are at least 18 inches (45 centimetres) above the counter tops. Remember to provide open vertical spaces for tall equipment such as enlargers. Shelving should be adjustable for easy access, even at the highest location.

MECHANICAL

Plumbing

Improperly designed plumbing can easily disrupt the routine in an otherwise efficient processing room. With careful materials selection and proper installation, you can avoid the troubles that result from an inadequate water supply, corrosion, or obstruction of the drainpipes.

Plumbing installations are most economical and efficient when all sinks and drains use a common drain along the outer walls of the darkroom area. This offers the additional advantage of making internal partitioning simpler and more flexible. To reduce condensation on cold-water pipes and prevent heat loss from hot-water lines, avoid long runs of uninsulated, exposed piping. Pipes that supply water to a sink should be high enough to provide a clearance of at least 16 inches (40.6 centimetres) between the sink bottom and the faucets. This allows room for a 1-gallon (3.8-litre) tank to sit in the sink beneath the faucets. The sink should have at least two faucets—a swing spout with hot and cold water and a cold-water faucet with a hose attachment for rinsing trays and other equipment.

Water Quality: An abundant supply of relatively pure water is essential to photographic processing. Make sure that you have an ample supply of water that is free from any contaminant detrimental to your processing operations.

Generally, municipal or public water supplies are sufficiently pure for photographic use. Such water almost always contains chlorine, and often contains fluoride. It may also contain traces of detergents, weed-killers, and insecticides. Fortunately, these substances are usually present in such small amounts that they do not adversely affect photographic materials or solutions. Excessively hard water can be troublesome in chemical mixing. Very soft water swells and softens the gelatin on film and paper during washing.

The hardness of water is measured in parts per million of calcium carbonate

($CaCO_3$). The following table gives the amounts of this substance contained in water described as soft or hard:

Water Hardness	ppm of $CaCO_3$
Soft	Less than 40
Moderately hard	40 to 120
Hard	120 to 200
Very hard	Over 200

The practical limits of water hardness for photographic use are 40 to 150 parts per million of $CaCO_3$. The local water authority or water company can usually provide information about a particular water supply. Because seasonal and other periodic changes may affect the condition of a water supply, the long-term monitoring by the water company is more reliable than the analysis of a single sample of the water.

Practical Limits for Common Impurities in Water for Photographic Processing

Impurity	Parts per Million
Color and suspended matter	None
Dissolved solids	250
Silica	20
pH	7.0 to 8.5
Hardness, as calcium carbonate	40 (preferable) to 150
Copper, iron, manganese (each)	0.1
Chloride, as free hypochlorous acid	2
Chloride (for black-and-white reversal)	25
Chloride (for color processing)	100
Bicarbonate	150
Sulfate	200
Sulfide	0.1

When you are evaluating any water source, and especially if you intend to use an undrinkable water supply or water from a well, have a sample analyzed. Water may contain impurities harmful to photographic materials. If the analysis shows a marked deviation from the amounts in the table above, consult a water-conditioning company to determine the most suitable method of treatment or filtration of the water. For small operations, treatment of water is often uneconomical.

Water Conditioning: Most water contains solid matter that must be removed by filtration. Usually a prefilter of 50-micrometre porosity serves the main water line; final filters of 25-micrometre porosity protect critical processes in the typical photolab. A 50-micrometre filter is fine enough to trap the larger particles of grit that cause physical damage to films and papers during processing. Filters of 25-micrometre porosity usually remove fine particles—such as clay, silt, mud, or silica—that cause turbidity.

Filters with replaceable cores are commonly used in processing laboratories. The interval between core changes depends on the time it takes for a filter to clog or for a reduction in water pressure across the filter to occur. Install pressure gauges before and after filter housings.

Water drawn from some wells or from other untreated sources is sometimes colored by colloidal iron or organic matter. Water in this condition can stain a photographic emulsion, but filtration with activated charcoal generally removes such impurities.

When water is heated, gas or air bubbles come out of solution, giving the water a milky appearance. This problem most often occurs when the incoming cold water is below 50°F (10°C). If these bubbles adhere to the surface of film or paper, they interfere with processing and washing. The remedy for this trouble is aeration of the incoming water. Aeration produces small bubbles that can help to disperse the larger ones.

In sinks used for manual processing, fit aerators on the water taps; most hardware stores stock these attachments. In mechanized processing, use a ballast tank to aerate the water. A ballast tank is an open tank in which the hot water and cold water mix. As air passes through the mixed water, larger bubbles take up the finer bubbles and disperse at the surface. If you use a hose in this operation, use an anti-siphon device to prevent backflow of water into the system.

Conservation of Water: In some areas, good water is in short supply and conservation is a top priority. Although you can save water in a number of ways during processing, taking the following steps when you install or equip new facilities provides more savings:

1. Do not use washers that are unnecessarily large. Reduce unnecessary water depth in washing tanks or trays. A greater rate of flow is necessary with deep tanks or trays to achieve satisfactory washing in the minimum time.

2. Insulate all long hot-water lines. This helps to save water by making hot water available immediately when the tap is turned on. At the same time, it saves money on the fuel used to heat the water.

3. For short-term-use prints, use KODAK EKTAMATIC SC Paper and stabilization processing. The KODAK EKTAMATIC Processor uses no water in print processing.

4. Use a working solution of KODAK Hypo Clearing Agent prior to washing. This preparation can save two-thirds or more of the water normally used to wash negatives and prints.

5. Use a KODAK Automatic Tray Siphon if you wash sheet materials in a tray. It provides better water circulation and exchange than water simply running into a tray from a tap or hose.

6. Use water-conservation devices for automatic processors. When a machine is standing by, conservation fittings automatically reduce the flow of water through the machine to that necessary to maintain solution temperatures.

7. Whenever possible, wash prints in three stages by arranging three washers in series—each one at a lower level than the preceding one. Fresh water from the upper tank will flow into the two lower tanks. Move prints at regular intervals from the lowest tank—where most of the hypo is removed—to the intermediate tank and then to the upper tank, where washing is completed by the incoming fresh water. Use an audible timer to signal the intervals to eliminate guesswork and avoid overwashing.

8. If fresh water is scarce, use seawater to wash films and prints. Salt water is very efficient in removing hypo from photographic material. However, residual sodium chloride causes fading of the silver image, especially when combined with residual hypo. Therefore, if you use seawater for washing, give a final wash of at least 5 minutes in fresh water for films; 10 minutes for single-weight prints, and 20 minutes for double-weight prints.

Water Distribution: The size of the main supply, or intake, pipe depends on the total amount of water needed in the installation. For small labs that do manual processing, a 1-inch (2.5-centimetre) pipe with ½-inch (1.3-centimetre) branches is satisfactory. In larger installations, particularly those with mechanized processing operations, a large-diameter supply pipe will probably be necessary. If you estimate the total water in gallons per minute that will be drawn at any one time, your plumbing contractor can determine the correct diameter of the pipe.

To determine the water usage rate, itemize the number and types of processes that require water and the total time that these processes will be in operation. Wash rates are usually recommended by the manufacturers of equipment and chemicals. Mechanized processor specifications call for a minimum flow rate and water pressure. Water may also be used for solution-tempering baths. Don't forget the water needed for chemical mixing, drinking, wash rooms, humidification, etc.

Water-supply pipes, solution-supply lines, and drains in removable floor trenches are accessible for repair, rerouting, or replacement.

The water-usage analysis should also indicate the requirements for water heating (or chilling) by considering the temperature of incoming water and the operating temperatures of processes. Along with the temperature differentials and flow-rate information, the plumbing contractor will need to know the peak demand and fluctuations of usage throughout the work day. With this information, he can determine the capacity and recovery rate needed in a hot-water heater.

In small-scale sheet-film processing, fluctuations in water pressure are probably no more than an inconvenience. In large-scale and mechanized production, however, both hot- and cold-water lines must have a water pressure of no less than 45 psi (310 kilopascal). To provide this, sufficiently large intake pipes must lead from the mains so that the maximum demand can be drawn without a drop in pressure. If the mains themselves cannot supply the necessary pressure, you will need a booster pump to raise the pressure.

If you anticipate increased demand, put in an intake pipe larger than necessary when the original plumbing is being installed. This is less costly and much more convenient than having to install one when the plant is in operation.

For supply pipes, copper tubing is only slightly more expensive than galvanized steel, and it is more durable and easier to install. It is particularly appropriate for concealed installations in walls or other inaccessible places. Another option is chlorinated polyvinyl chloride (CPVC) pipe, which can withstand high water temperatures. Check your local building code to determine if this material is approved for your area.

Do not fit cast-iron or galvanized pipes directly to stainless-steel sinks. Connect them with copper fixtures extending at least 4 inches (10.2 centimetres) from the sink. Iron and its compounds can react with stainless steel and cause corrosion.

Use either gate or globe valves for control in the water system. The gate valve is either completely open or closed. Use it as a shutoff, not as a flow regulator, because it is liable to be noisy. The globe valve regulates flow quietly.

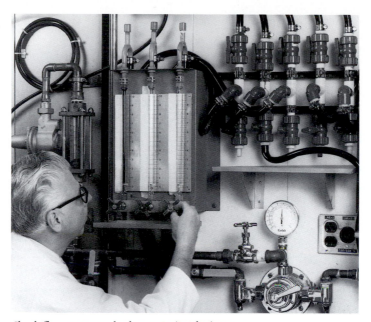

Check flowmeters and other metering devices regularly to be sure they are delivering the correct amount of solution.

Water-Temperature Control: Accurate, consistent control of processing conditions is essential. Particularly critical is control of solution temperatures in color processing.

When you process only small amounts of photographic materials, you can get along with manual adjustment of temperature. For example, you can fit the drain of the darkroom sink with a standpipe and allow water from an ordinary mixing faucet to surround processing tanks to the level of the standpipe. Place a thermometer in the water flow and monitor the temperature to make sure that varying loads on the water-supply lines do not change the temperature of the bath.

If you process large amounts of sensitized materials, manual temperature control is cumbersome. Therefore, you will need an automatic temperature-control system that is both accurate and dependable. The following types of equipment are available for maintaining uniform solution temperature:

Immersion Heaters: Small immersion-heater units control the temperature of the water bath in which the processing vessels stand. These units maintain the water temperature in the bath within plus or minus ½°F (0.3°C) and are capable of tempering several cubic feet of water. Most of these units have an electrical heater element, an agitator or circulator pump, and a temperature-sensing device.

Mixing Valve: If you need a large supply of tempered water, a thermostatically controlled mixing valve provides an inexpensive alternative. The valve operates by mixing hot and cold water to obtain the required temperature. The valve should deliver at least 3 gallons (11 litres) of tempered water per minute, control the temperature of the mixed water within plus or minus ½°F (0.3°C), and recover quickly from variations of pressure and temperature in the water lines.

Water Chillers: In some areas, the temperature of the incoming cold water may be too high for some types of photographic processing, e.g., black-and-white processing. Under these conditions, you must have an auxiliary water chiller or install a sink unit equipped with a chiller.

Recirculation Units: Tempered-water recirculating units can provide valuable savings in water usage. These units have both a heating and a chilling capacity and can be connected to a sink or a water jacket that surrounds a tank.

Vacuum Breaker: If the installer connects the tempered-water-line outlet below the surface of the water in a water bath, water jacket, or wash tank, he should also install a vacuum breaker on the supply pipe from the temperature-control unit. This fitting prevents contaminated water from the tank from being siphoned into the water lines if the main supply fails or is shut off. Both drinking water and processing solutions can be contaminated in this way.

Processing Sinks: Units made of stainless steel, fiberglass, or inert plastic materials are suitable for photographic purposes. Many of these sink units have taps, mixing valves, water filters, and a vacuum breaker already fitted. Plumbing on site is confined to connecting the water and drainpipes. A further refinement is a completely self-contained, manual color-processing unit that has built-in water-jacketed tanks and fittings for all services including nitrogen-burst agitation.

A local sheet-metal company can often fabricate stainless-steel sinks to your specifications. Because certain welding and passivation techniques are necessary for sinks intended for photographic purposes, have the work done by an expert.

Homemade Sinks: If you are unable to justify the cost of the manufactured unit, you can make serviceable sinks by using a wooden form covered with several laminations of fiberglass cloth and a suitable polyester resin. The technique of coating the form is essentially the same as that used to cover the hulls of small boats.

Use polyester resin and a suitable catalyst for wooden surfaces; epoxy resin is more suitable for bonding to metal. Make sure that the wood is clean and free from grease or dust. To obtain an effective bond, roughen the wood surface with fairly coarse sandpaper. You can color the resin to match the color of the room.

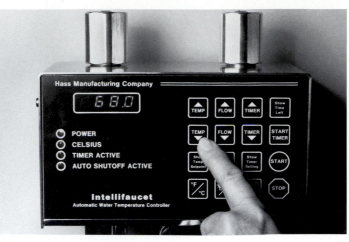

Water-temperature control is easy with new electronic metering devices; this one has an LED temperature indicator for easy reading. Photo courtesy of Hass Manufacturing Company, Troy, NY.

Follow these safety rules:
- Familiarize yourself with any precautions or any warnings on the product labels and in the instructions.
- Mix and apply the resin in a well-ventilated place.
- Use a respirator-type face mask.
- Do not smoke near the chemicals.
- Wash your hands frequently.

Placement of Sinks: Reduce the cost of plumbing by locating sinks where the same drains and water supplies can be used for other equipment in adjacent rooms. For example, the darkroom sink and a washing tank in the finishing room could have common plumbing if they are close to one another on opposite sides of a wall.

In black-and-white print processing, it is rarely convenient for more than one person to use the same set of processing trays. If more than one person must work at a sink, place it near the center of the darkroom so that operators can work at both sides of a wide sink at the same time. This type of design is common in instructional darkrooms. A shelf suspended above the sink carries the water pipes and taps. However, the shelf should not extend over the developing trays, because it could cast a shadow or interfere with the handling of large prints.

Duckboards: Use duckboards of moisture-resistant cypress in the sink. Installed in sections, they can be removed readily for cleaning the sink. If the slats are triangular-shaped instead of flat, more water will come into contact with the bottoms of developing tanks or trays, making it easier to control the temperature of the solutions. Corrugated fiberglass roofing material and the plastic grilles normally used over fluorescent lighting units, supported by short sections of PVC pipe are also suitable for duckboards. Typical lighting grilles are 26 x 50 inches (66 x 127 centimetres) and have a honeycomb pattern of squares or circles.

Duckboards made from corrugated fiberglass resist chemical attack and do not absorb moisture.

Tray Storage: Store trays by standing them vertically between separators in a removable tray rack. This permits easy access and cleaning of the storage area, and at the same time allows wet trays to drain. In addition to the tray racks, provide shelf space under the sink for chemicals, extra tanks, and other processing equipment. This type of setup is illustrated on page 20.

Gaseous-Burst Agitation: To process color materials, provide a gaseous-burst agitation system. Install this with a set of tanks in an ordinary processing sink, or buy a processing unit with nitrogen-burst fittings already in place. The elements of a gaseous-burst agitation system for developers include a tank of nitrogen at an initial pressure of 2000 pounds per square inch (13,800 kilopascals), a pressure regulator or control valve, an intermittent gaseous-burst valve, and gas distributors to fit the tanks. The pressure regulator reduces the gas pressure to 15 pounds per square inch (about 100 kilopascals).

In most cases, you will use compressed air in solutions *other than developers;* For example, aeration of solutions such as bleaches and bleach-fixes is critical for oxidizing the exhausted bleach and avoiding problems such as retained silver and leuco cyan dye. However, make sure that the compressor delivers *oil-free air.* For more information about nitrogen-burst agitation, see KODAK Publication No. E-57, *Gaseous-Burst Agitation in Processing.*

Drainage Systems: Sink drainage lines must be able to accommodate the maximum flow of water from the sinks and should be at least 2 inches (5.1 centimetres) in diameter. The flow capacity through a drainage line depends not only on its size but also on the pitch of the pipe. The National Bureau of Standards and the National Plumbers Association recommend that the pitch be at least ¼ inch per foot (0.6 centimetres per metre). It is always good practice to flush the drain with rapidly flowing water after discarding processing solutions. This minimizes corrosion and washes away any leftover sludge or gelatin.

To withstand the chemicals it will carry, the drain should be acid- and corrosion-resistant. It should be able to withstand rapid changes in the temperature of the water without cracking. Provide a wide margin of safety by choosing a material that is resistant to full-strength processing solutions. Some of the common drain materials are described below:

Stainless Steel: The common chromium-nickel stainless steel, A.I.S.I. Type 304, is more corrosion-resistant than cast iron. Chromium-nickel molybdenum stainless steel, A.I.S.I. Type 316, is more corrosion-resistant and more expensive than Type 304.

Cast Iron: This is the most commonly used material for waste pipes and fittings, although it will eventually rust in the presence of corrosive solutions. The pipe quality should be extra heavy and must comply with Federal Specification WWP-401.

Black Steel: This material is widely used for drains, but the acid in discarded fixers tends to corrode it. Drain lines will last longer if you use extra-heavy or double-extra-heavy pipe in place of standard-weight pipe.

Galvanized Steel: This pipe has a light coating of zinc. Because acid solutions remove the zinc coating rapidly, there is no advantage in using galvanized steel instead of black-steel pipe.

Brass and Copper: Acid solutions rapidly corrode these metals. Do *not* use them for darkroom drains.

Plastic: Various plastics, such as acrylonitrile butadiene styrene (ABS), polyvinyl chloride (PVC), and chlorinated polyvinyl chloride (CPVC) can serve as drainpipe material. These plastics have excellent corrosion resistance and adequate mechanical strength; they can be used in drain lines as long as the waste water normally discharged is below 135°F (57°C).

Drains can last indefinitely if chemical solutions, particularly acid solutions, do not stand in the traps and pipes. After discarding processing solutions, flush the drains thoroughly with cold water. Waste matter left in sinks can clog drains. Avoid loss of production, as well as costly water damage caused by an overflowing sink, by keeping sinks clean and free of debris.

Waste Disposal and Treatment: Local regulations and conditions dictate the approach you must take toward this vital concern. Your plans must meet the requirements of your community. Contact your department of public works for information on both water supply and waste disposal.

If you have a septic system, this is not a concern. But you should know that an excessive volume of processing solutions may temporarily impair a septic tank. The tank will regain its normal activity after it is sufficiently diluted. With a 300- to 500-gallon (1140- to 1890-litre) septic tank, additions of about 40 gallons (151 litres) of solutions per day will have no adverse effects.

If your photoprocessing waste enters the local sewer system, you will need a permit to discharge wastewater. Requirements, conditioned by local concerns, can change rapidly. Therefore, we have not attempted to cover acceptable discharge procedures here. The Kodak publications listed below include current waste-treatment procedures and recovery of silver from solutions.

Choosing the Right Silver-Recovery Method for Your Needs, KODAK Publication No. J-21. Describes metallic replacement and electrolytic methods of recovering silver from processing effluent and compares which is appropriate for certain operating conditions.

The Use of Water in Photographic Processing, KODAK Publication No. J-53. Discusses the theory of photographic washing and describes how to improve washing efficiency and conserve water.

Disposal and Treatment of Photographic Effluent, KODAK Publication No. J-55. Describes photographic processing effluents and ways of reducing and treating large volumes.

Heating, Ventilating, and Air Conditioning

Clean, fresh air not only helps your workers feel good, but it also avoids fume-related health problems. And it's necessary for high-quality processing and safe handling and storage of photographic materials.

Processing produces odors and fumes, high humidity, and heat (from lamps, electric motors, dryers, mounting presses, and high-temperature processing solutions). So it is important to supply plentiful clean, fresh air at the optimum temperature and relative humidity into all processing rooms.

Modern ventilation systems filter, supply, and distribute air, keep it moving, control its temperature and humidity, and adjust its pressure. If you are planning a large photographic plant, consult a ventilation and air-conditioning engineer as early as possible in the planning stage, because the design of an air-conditioning system involves a complex assessment of all the conditions that will exist inside and outside the building when the plant is in operation. If the designer has the opportunity to make suggestions in the early stages of planning, the result might well be increased efficiency and lower operating costs.

Air Supply and Movement: The volume of incoming air should be sufficient to change the air in a processing room completely in about 8 minutes. The flow of air should be diffused or distributed to avoid objectionable drafts. Apart from causing personal discomfort, drafts can cause dust problems and can disturb the uniformity of surface temperature on drying drums and other heated equipment.

You need exhaust hoods for these operations: print drying in continuous processors, film drying in heated cabinets, chemical mixing, sulfide toning of prints, print lacquering, and certain steps in color processes. In all cases, follow the safety recommendations on the chemical labels and in the instruction sheets packaged with the chemicals and in Material Safety Data Sheets.

For automated processing equipment, supply tempered fresh air from above the feed or head end of the machine at a minimum rate of 150 cfm (4.3 cubic metres per minute). If the machine extends through a wall into another room, ventilate both rooms.

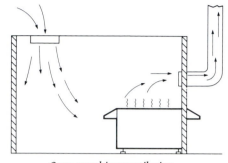

Open-machine ventilation.

Install exhaust outlets to remove humid or heated air and chemical vapors directly to the outside of the building. Exhaust the room air from an open machine or tank area to the outdoors at a minimum rate of 170 cfm (4.8 cubic metres per minute) per machine. An exhaust rate higher than the supply rate produces a negative pressure and reduces the chance of vapors or gases escaping to adjoining rooms. The ideal position of the exhaust opening is near the stabilizer tank for Process C-41 or E-6 or near the bleach-fix tank for Process RA-4 or EP-2. Position the exhaust opening so that the flow of exhausted air is away from the operator as shown here. Do not recirculate this air.

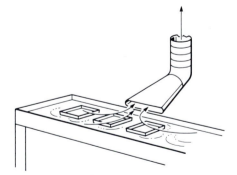

Open-tray exhaust ventilation from a processing sink.

If the processing tanks are enclosed and are equipped with an exhaust, you can reduce the minimum room-air supply rate to 90 cfm (2.5 cubic metres per minute) and the air-removal rate to 100 cfm (2.8 cubic metres per minute) per machine. See the drawing below. For efficient removal, always place the exhaust opening as close as possible to the source of the contaminant. For a processing tank, use an exhaust hood with a narrow opening placed at the back of, and level with, the top edge of the tank.

A cone-shaped exhaust hood used over the drying drum of continuous paper processors extracts heat and moisture. Vent the dryers to the outside of the building to avoid undesirable humidity buildup. Use a similar hood over a sulfide-toning sink to vent hydrogen sulfide. However, be sure to place the exhaust duct on the side opposite the operator so that the vapor will not be drawn toward the operator's face.

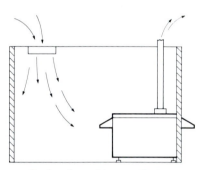

Enclosed-machine ventilation.

Provide a well-ventilated room for mixing the chemicals used for color processing and for high-volume black-and-white work. The room should have one or more movable exhaust hoods that provide a capture velocity of 100 fpm (30.5 metres per minute). The drawing on page 43 shows a suitable mixing-tank arrangement.

If you plan to lacquer prints regularly, you need a spray booth. A concentration of lacquer spray in a room is both hazardous and very objectionable to personnel. A spray booth is a large box—at least 6 feet high by 3 feet wide and 3 feet deep (2 x 1 x 1 metres)—equipped with a ventilation hood, an exhaust fan, and an air duct that

discharges the contaminant into the open air, outside the building. The booth is open at the front. The more enclosed this operation is, the more efficient the carry-off of excess spray will be. Situate a filtered exhaust outlet toward the back of the booth so that the vapor is drawn away from the operator.

In designing exhaust hoods and spray booths, make sure that harmful contaminants are vented outside the building and not into the main exhaust duct of the ventilation system, where they could be recirculated into the work rooms.

Design for mixing-tank ventilation.

Temperature and Humidity:
Temperatures between 65 and 75°F (18.5 and 24°C) and a relative humidity between 45 and 50 percent are compatible with photographic work. These ranges also provide comfortable working conditions for most people.

In all color processing and in continuous processing of black-and-white papers and films, maintaining specific temperature and relative humidity is essential. The temperature of processing solutions must remain within narrow tolerances; this is much easier to do if the room temperature is constant.

Excessive humidity in the lab is uncomfortable for your personnel, and it has adverse effects on photographic materials. It causes erratic behavior of electronic measuring devices and inconsistent operation of electronic components in automatic printers. As a result, measurements of density may be inaccurate, and exposure times may be incorrect.

Very low humidity causes respiratory discomfort in people, static buildup on film and equipment, curl and brittleness in photographic paper, and evaporation of solutions in open trays. Static charges on film attract dust; they also cause discharge markings that can ruin negatives.

Air conditioning is the answer to supplying air at the optimum temperature and relative humidity. In almost any climate, a ventilation system that cools and dehumidifies the air in hot weather and warms and humidifies it in cold weather is necessary. Such a system can also provide air from which most of the dust has been removed—an important requirement in a photolab.

Although the cost of an air-conditioning system may seem high in relation to the duration of hot weather in your area, it is a worthwhile investment, especially with respect to humidity control.

Air-Conditioning Systems: The right type and size of air conditioner for a number of factors. The amount of space, the climate, insulation in walls and roof, materials of construction, number and size of windows, presence or absence of direct sunshine, and the color of roof and walls all have a bearing on the cooling capacity required. Also, the heat radiated by dryers, mounting presses, and high-temperature color processes adds to cooling requirements. An experienced air-conditioning engineer is best able to assess the needs of the lab and make the proper recommendation.

Air-conditioning systems are available in many types and with a wide range of cooling capacities. Heating and cooling systems that include mechanical humidifiers and electronic air filters are now combined. This type of combined system is probably the most suitable for a new building or one that is being extensively modernized. If you already have an efficient forced-air heating system, you might add a cooling unit that uses the existing blower and ducts.

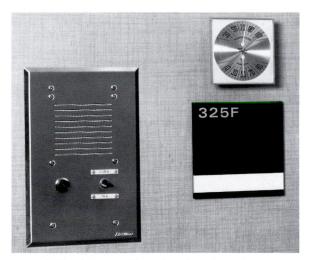

Monitor temperature and humidity throughout the lab with gauges like these mounted next to the darkroom intercom.

As an alternative to the combined heating and cooling system, you can use a self-contained air conditioner to cool and dehumidify several rooms on the same floor. This is a reasonably priced system for a small studio or an in-plant photographic department. Because an air conditioner must dissipate considerable amounts of heat and moisture, install self-contained units in an outside wall. You can install a unit in a suitably placed window, but it is better to install a large unit in an opening cut in the wall. It will fit better, and proper caulking around the unit will prevent drafts and dust from entering the room. Since heat from the sun decreases the efficiency of such a unit, put it in a northern wall of the building or in a shaded location.

Individual room-type air conditioners will cool one or two smaller rooms adequately. These units are available in many sizes. Be sure to buy one that has the correct cooling capacity for the room, and be sure that the electrical supply for the unit is sufficient. Too small a unit will be overloaded and will not perform efficiently; one with too large a capacity will cost more and will tend to have very short cycles and be wasteful in operation.

Air Cleaning: Most air-conditioning systems have efficient filters to clean the incoming air. Electrostatic air-cleaning systems can be added to improve air quality further.

In designing work rooms, you can minimize dirt and dust by making the floor beneath processing sinks, washing tanks, and benches accessible for cleaning; by avoiding dust-holding ledges and overhead surfaces that are too high for easy cleaning; and by providing air ducts with clean-out openings that allow removal of accumulated dust.

Most ventilation systems provide a positive pressure inside the building so that unfiltered air does not enter through doors and other openings. Differential pressure should exist between areas where contaminants are handled and rooms where sensitized goods are used or stored. The air pressure in a chemical-mixing room, for example, should be slightly lower than that of the adjoining rooms so that air will flow into the contaminated area rather than out.

ELECTRICAL

The electric wiring and equipment in a photographic plant must conform to the regulations of the National Board of Fire Underwriters. Also, all electrical work, whether a new installation or an alteration to an older one, is subject to both state and local approval. These regulations are necessary to safeguard the worker as well as the plant. Also, you must follow these rules so that insurance policies remain valid.

Electrical work is never a do-it-yourself project, unless you happen to be an electrician. A competent electrician should handle all technical matters relating to the installation, because faulty electrical work is particularly dangerous in the wet and dark conditions of a processing room.

Power Requirements

Electrical circuits designed for 30-ampere loads are adequate for darkrooms, unless you intend to install mechanized processing equipment. Some machines require power in excess of 30 amperes. The drying sections of automatic film processors are particularly heavy consumers of current. Requirements vary with the type and number of machines; calculate the total power consumption before planning the installation. Tell your contractor the voltage and amperage of each piece of equipment.

Electrical requirements for each piece of equipment are available from the manufacturer's literature or the machine nameplate. Also consider

future power needs, because additions to the plant always place an extra load on the power supply. It is wise to make provision for future expansion in the original installation.

Many pieces of mechanized equipment—as well as any but the smallest air conditioner—operate on 220-volt service. Therefore, an electrical installation for photographic work must include a 220-volt supply as well as the usual 120-volt supply.

Some types of electrical or electronic equipment require isolation from the effects of other equipment. You will have to use a voltage regulator with many enlargers, printers, and densitometers to restrict the input voltage to a narrow range, and provide dedicated lines to the equipment. Follow the equipment manufacturers' recommendations for the appropriate voltage regulator to use.

Safety and Convenience

The following suggestions will help you to install a safe and convenient electrical system:

1. Install reset-type circuit breakers instead of replaceable fuses. Locate breakers close to the area served by the circuit.

2. Separate the lighting circuits from the equipment circuits. You will then continue to have darkroom lights in case of an equipment overload. Each printer or enlarger should have its own dedicated circuit.

3. Install constant-voltage transformers to minimize the effect of voltage fluctuations on printer and enlarger lamps. Changes in voltage cause changes in the color temperature of tungsten lamps; this in turn alters the color balance of color prints and transparencies. Maintaining constant voltage is essential in color work.

4. Install at least five double outlets in a small darkroom. Locate them about 45 inches (110 centimetres) from the floor. If they are too low, you must pull equipment away from the wall to insert or remove a plug.

5. Do not place electrical outlets in wet locations. An outlet too near a processing sink, for example, may be splashed with chemical solutions and water. If an outlet in such a location is essential, be sure it is the ground-fault interrupter type.

6. Use foot switches for convenience in enlarging, but equip them with long cables so that you can move them if a spill occurs.

7. Use a lamp socket with a built-in switch for each of the safelights. You can then switch off any lamp independently of the others.

8. Control all processing-room circuits with a master switch located about 6 feet (1.8 metres) from the floor. However, make sure that refrigerators, freezers, and electric clocks are not affected by the switch. Install the white-light switch just below the main switch; place the safelight switch below the other two, about 45 inches (110 centimetres) from the floor. Accidentally turning on white lights in a film-processing room can be an expensive and embarrassing experience, particularly when customers' materials are involved. To avoid such an accident, install a guard on the white-light switch.

9. Install ground-fault interrupters (GFI's) in high-hazard areas such as chemical-mixing rooms and darkrooms. Have your electrician ground all metal objects in a darkroom.

10. Install recessed lighting fixtures and safelights in the ceiling for more headroom. Older fluorescent lamps retain an "afterglow" that can fog film several minutes after the lamps are switched off. While this effect has been eliminated with newer lamps, many lab workers prefer to have tungsten lamps just to be on the safe side.

Light switches equipped with a guard or locking plate are unlikely to be snapped on inadvertently in the darkroom.

Communications

Staying in touch in a photographic lab can be difficult. Communications are an important part of the organization's productivity and convenience.

Intercom Systems: A system that lets you speak to processing-room and other personnel throughout the plant is valuable. It saves the time spent walking from place to place or using internal telephones. Any intercom system used in darkrooms should permit the processing-room operators to reply to a call without leaving their work and without handling switches or pressing buttons.

Telephone Systems: For many small labs that need to communicate with outside clients as well as lab personnel, telephone systems that combine standard phone and intercom functions are available. Many have other features such as "call waiting" that can help lab efficiency.

Music: Music broadcast over a loudspeaker system provides a relief from monotony. It should not be loud enough to interfere with normal speech. The reproduction must be of good quality, or it will be merely irritating. A number of companies transmit suitable music as a commercial service to businesses. The Yellow Pages of the local telephone directory list the names and addresses of these companies.

Another option is to feed a speaker system with your own music (tape, CD, or commercial radio station). The content must be acceptable to all employees as well as customers.

Appendices

APPENDIX A Hiring an Architect

Interview at least two or three architects. Ask for references. Discuss the scope of their services, schedule, fees, and philosophy.

Scope of Services

Architects can provide any or all of the following:

Preliminary Services: Advice on site selection or feasibility. This can include the measuring of an existing building.

Programming: A written description of your needs as the basis for design.

Preliminary Designs: Sketches of alternate arrangements that will satisfy your requirements.

Design: Drawings of the final arrangement, based on your review of the preliminary designs.

Contract Documents: Sometimes called working drawings and specifications; documents that describe the work in detail. They are used for competitive bidding and for construction of the building.

Bidding: The architect can help you find qualified bidders who are interested in doing the work.

Contract Administration: The architect will visit the work site from time to time to assist the contractor with interpretation of the contract documents and to verify that the work conforms to the documents. The architect will also determine what payments have been earned by the contractor.

Schedule

Ask the architect for a proposed schedule of services. Keep in mind these important points:

1. How quickly you make decisions during the design process will have a direct effect on the schedule.

2. Unless you are under great economic pressure to complete the work rapidly, take time to enjoy the design process and consider your options as the design progresses.

Fees

Do not be reluctant to discuss fees with the architect. Discuss both fee arrangements and fee amounts. The following are common arrangements you can make:

1. Base fees on a percentage of construction cost.

2. Determine an hourly rate.

3. Make one lump-sum payment.

4. Pay a lump sum plus expenses.

The amount of the fee varies with the complexity of the project. Fees are usually based on a percentage of construction costs, with the architect providing full services. For example:

1. 10 to 15% of construction costs for a custom-designed building.

2. 6% or more for an average commercial building.

3. 3 to 4% for a simple structure, such as a warehouse.

Philosophy

Each architect works differently from every other architect. Differences in training, age, and personal likes and dislikes all affect the architect's work and relationships with clients. Discuss these items with each architect you consider to get a feel for his compatibility with you and your needs. Talk with the architect about past work and experiences. Ask him what he considers important in his work.

Reproduced with the permission of Bero Associates, Architects, ©1989.

APPENDIX B Photolab Plans

The layouts on the following pages are designed for specific photolab needs. You may be able to use one of these plans or adapt it to your needs without extensive alteration. Study the plans to be aware of alternatives.

If no one plan satisfies all your needs, combine parts of several plans.

Study the layouts to establish a continuous workflow and efficient space utilization. Visit other photolabs of similar size and character to the one you are planning. Ask them if they have a floor plan. It helps to relate the location of actual rooms and equipment to the placement on a plan.

For your convenience, plans are grouped according to lab type: photo-journalism, industrial, law-enforcement, portrait/commercial, professional finishing, and photo-education. Wherever possible, the scale of the plans is ¼ inch to the foot. Note the reference scale next to each plan.

PHOTOJOURNALISM

Design 1: A basic plan for a one-photographer darkroom for black-and-white film processing and printing in 48 square feet (4.5 square metres).

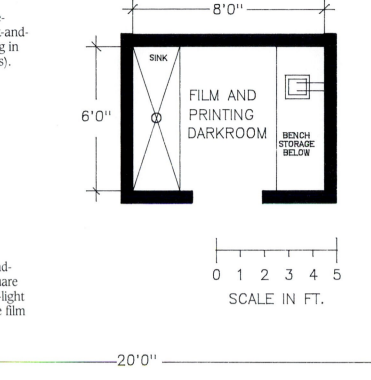

Design 2: A two- to five-photographer lab with a black-and-white paper processor in 280 square feet (26 square metres). A white-light work area is common to separate film and print darkrooms.

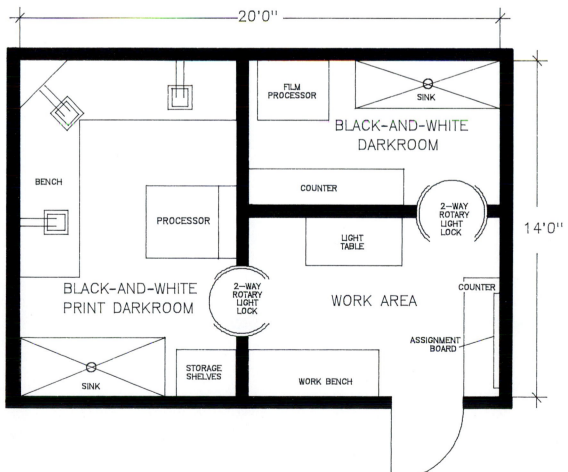

PHOTOJOURNALISM

Design 3: A four- to six-photographer photolab in 400 square feet (37 square metres). The lab is a modification of Design 2, with a small camera room added. This layout can accommodate occasional color work.

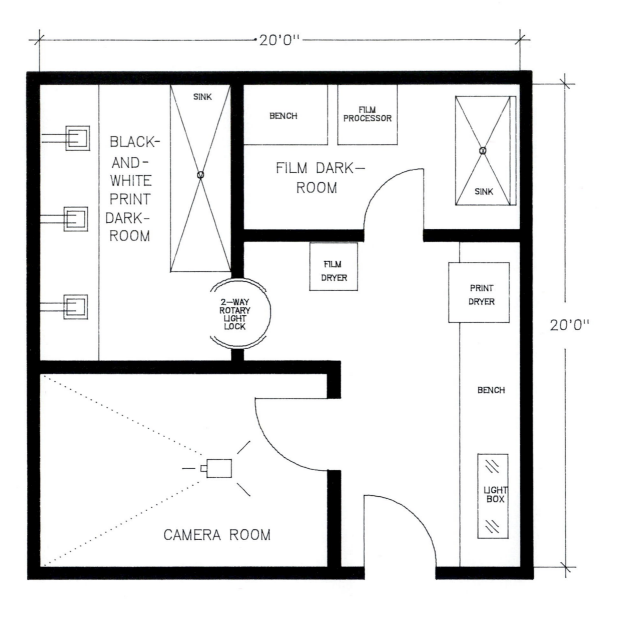

SCALE IN FT.

Design 4: This lab includes two small color processing darkrooms and an editing area. The design provides a choice of processing film manually or by machine. Black-and-white operations make up a large part of the work, as indicated by the machine processors. Manual sink processing for color and black-and-white accommodates unusual sizes or special processes. A quality-control area is included in the 620 square feet (57.6 square metres).

SCALE IN FT.

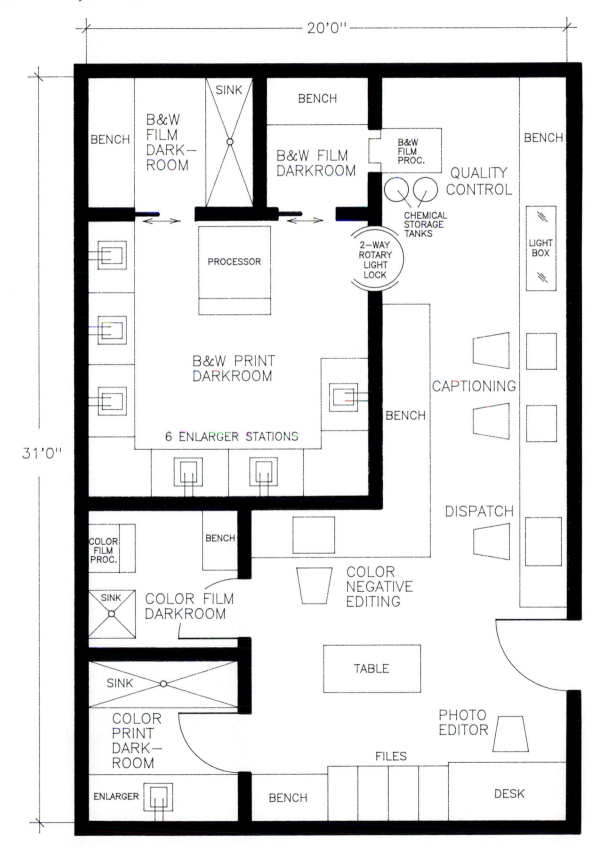

INDUSTRIAL

Design 5: The optional light-trap entrance allows personnel to enter while someone else works uninterrupted in the dark. This layout can accommodate color or black-and-white operations, depending on the equipment selected. The area of 135 square feet (12.5 square metres) can accommodate one or two workers.

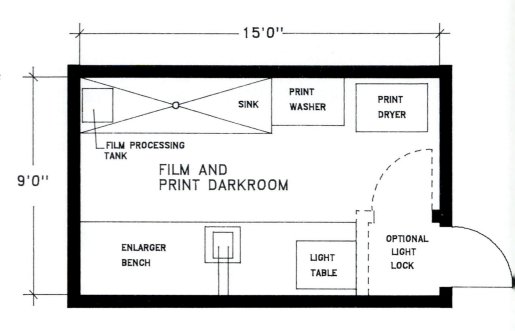

Design 6: Film and print processing are separated, and a small white-light finishing room has been added to this layout. Two people can work comfortably in the 179 square feet (16.6 square metres). Note that this design is similar to Design 2; both can accommodate color work with appropriate equipment.

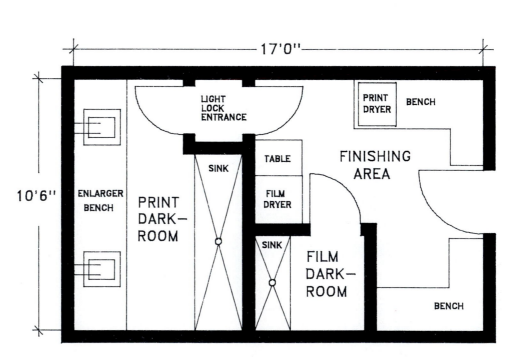

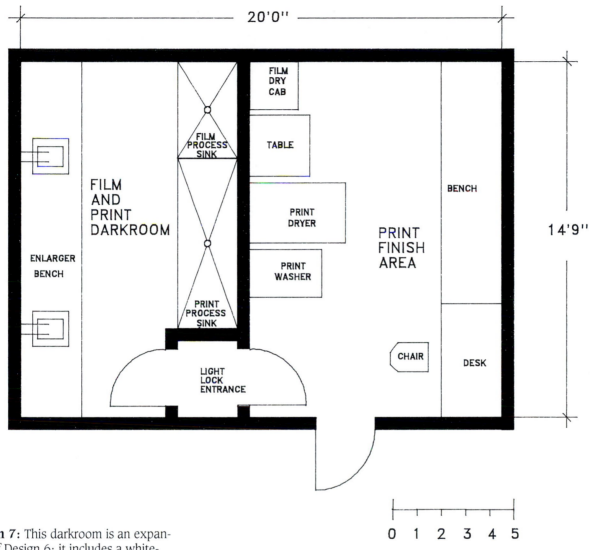

20'0"

14'9"

FILM
DRY
CAB

FILM AND PRINT DARKROOM

ENLARGER BENCH

FILM PROCESS SINK

TABLE

PRINT DRYER

PRINT FINISH AREA

BENCH

PRINT WASHER

PRINT PROCESS SINK

CHAIR

DESK

LIGHT LOCK ENTRANCE

0 1 2 3 4 5

SCALE IN FT.

Design 7: This darkroom is an expansion of Design 6; it includes a white-light finishing room and a light-trap entrance to the darkroom. Even though the lab is designed for manual processing, it can be equipped with small tabletop processors without renovating the room. One to two people can work in the area of 295 square feet (27.4 square metres).

INDUSTRIAL

Design 8: The studio in this plan is supported by black-and-white, color negative, and reversal film and print processing. Equipment is available to provide both automated and manual processing. The printing darkroom has space for a KODAK ROYALPRINT Processor, Model 417, to achieve lab automation for black-and-white print processing. The large, divided camera room allows for I.D., advertising, and product photography; portraiture; and copywork. The area is 960 square feet (89.2 square metres).

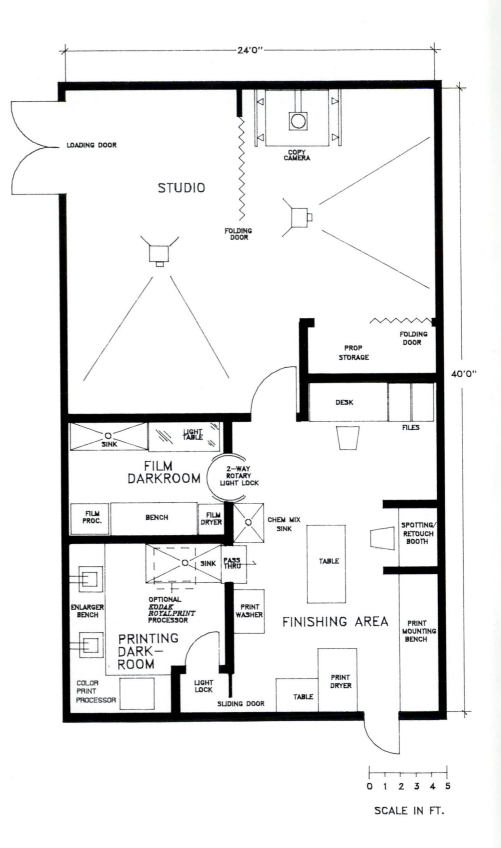

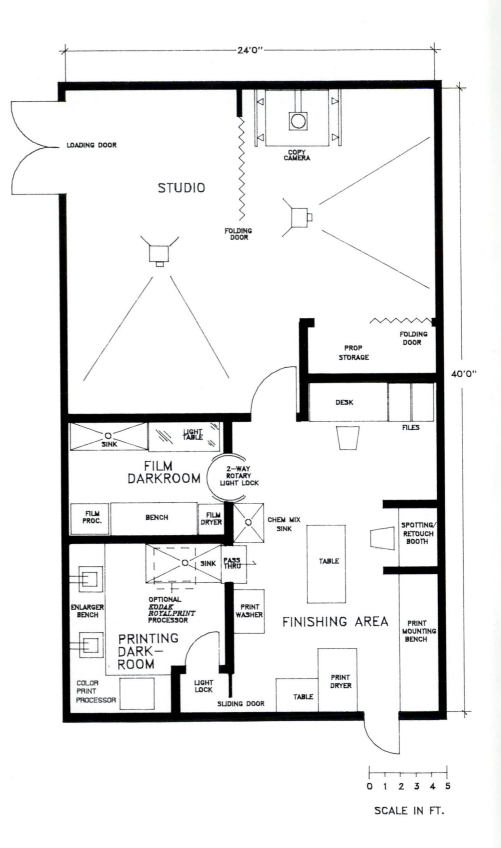SCALE IN FT.

LAW-ENFORCEMENT

Design 9: The long, narrow shape of this law-enforcement lab features a wide center aisle for easy access to all darkrooms. This center aisle allows for work to flow into the central finishing area before delivery. Two special-purpose rooms are set aside for evidence photography and laser/infrared analysis. The total area is 1200 square feet (112 square metres).

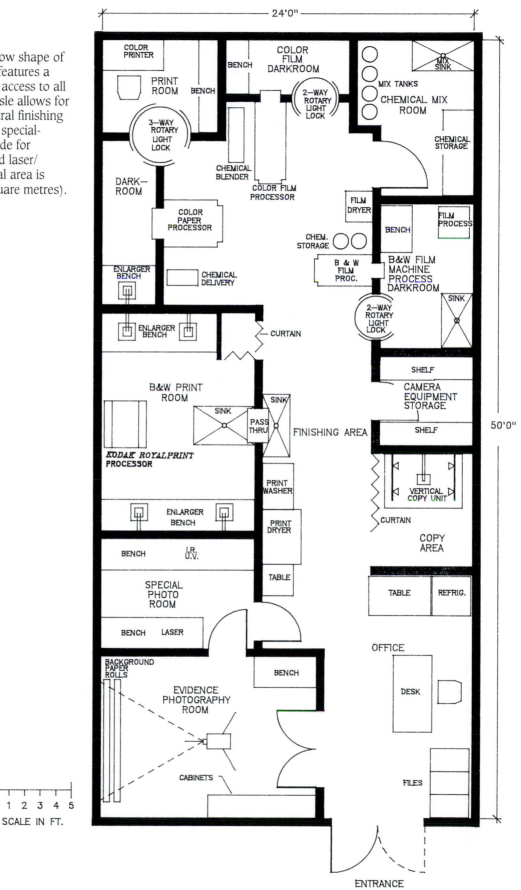

PORTRAIT/COMMERCIAL

Design 10: This plan accommodates both commercial and portrait customers. The spacious reception area includes a sales-presentation room. The processing lab is capable of handling black-and-white and color processing. The studio is divided by a folding door to keep portrait work separate from commercial-area activity. Room for expansion or storage is included in the 2295 square feet (213 square metres).

SCALE IN FEET

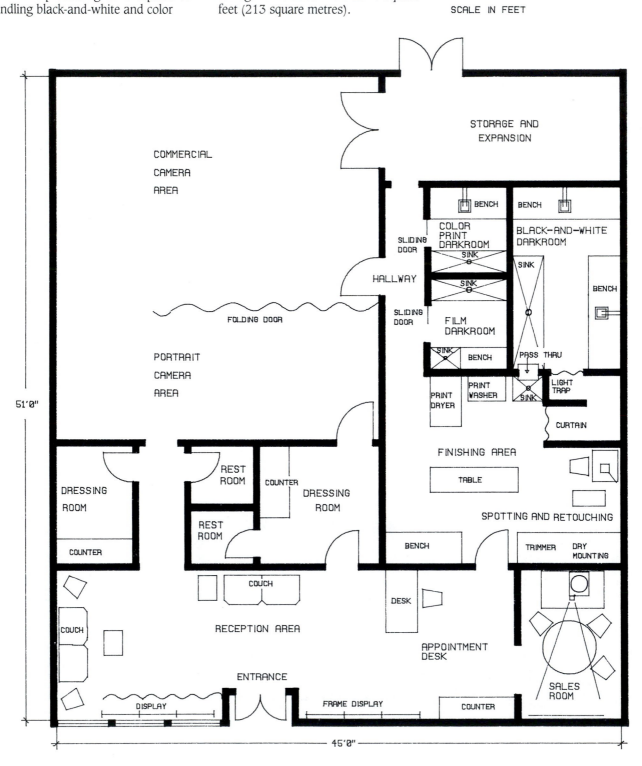

Design 11: For the studio that is totally dedicated to portrait work, this design is tailored for the kind of space that would be available in most shopping centers. The layout features a complete in-house finishing service.

Also note that it is a variation of Design 10; less space is devoted to the reception area and more to the finishing area. The space is 2624 square feet (244 square metres).

SCALE IN FEET

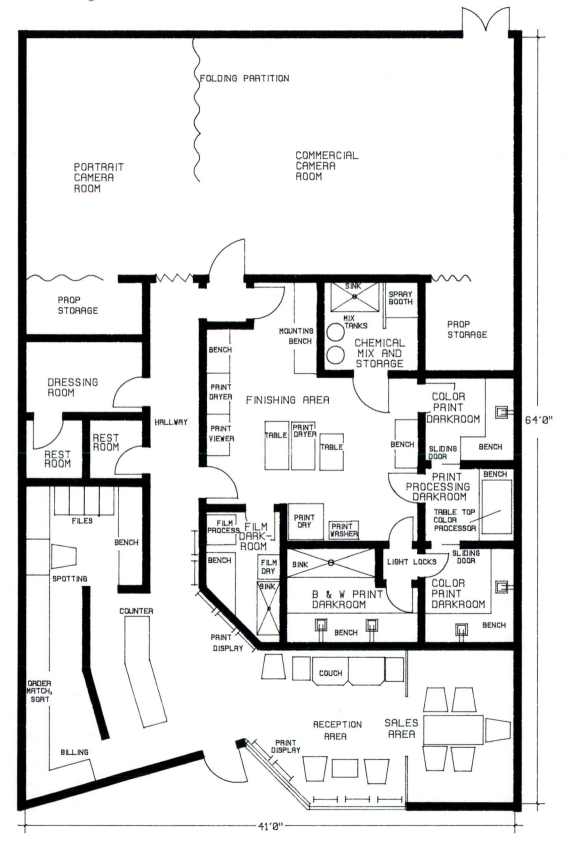

PHOTO-EDUCATION

Design 12: This instructional photolab is designed to accommodate a maximum number of students in a minimum amount of space. It includes 15 work stations for black-and-white printing and 8 individual color darkrooms. Up to 15 students can be seated in the classroom or studio at one time. A print-inspection booth at the end of the black-and-white printing darkroom keeps stray light from interfering with group printing. The two S-type light traps for the two large darkrooms allow students to move quickly and easily from the darkrooms (rotary light-locks handle one at a time). The area is 3135 square feet (291 square metres).

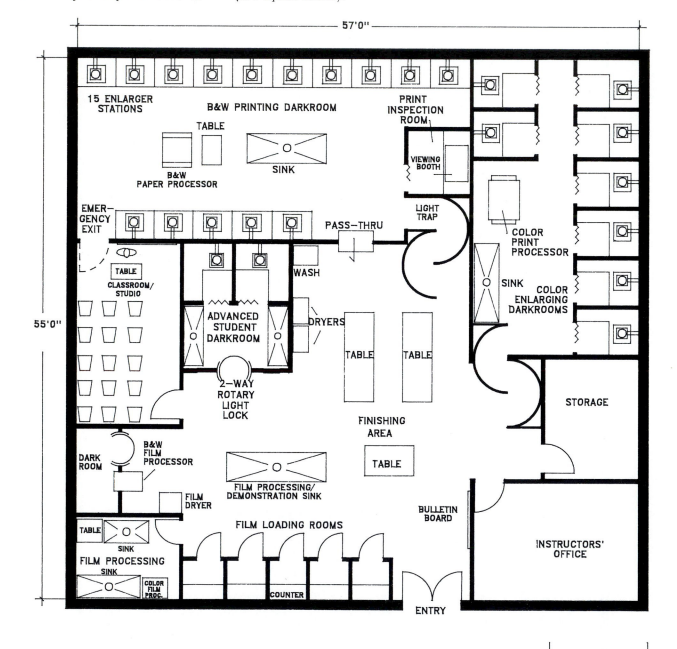

PROFESSIONAL FINISHING

Design 13: The design of this small professional lab concentrates on color negative printing and processing within the 1400 square feet (130 square metres). Other types of finishing are sent out. The lab is equipped for automated and custom printing. A reception area allows walk-in trade; a separate area is provided for direct-mail shipping.

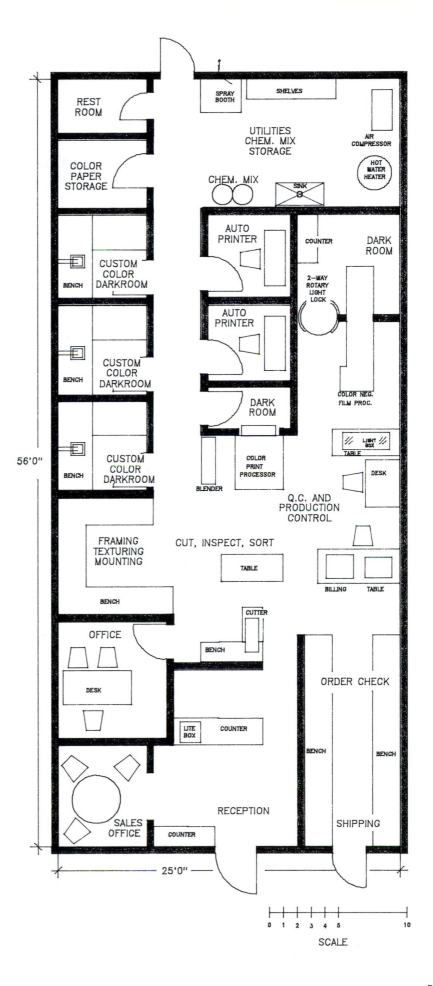

PROFESSIONAL FINISHING

Design 14: This layout makes use of a long, narrow building to provide a variety of processing services. The main center aisle doubles as a production space and provides access to all lab areas. All processed work flows to the middle of the lab for finishing, then to the front for final checking and billing. The lab complements its services with a minilab as well as video-transfer capabilities. The total area is 3864 square feet (359 square metres).

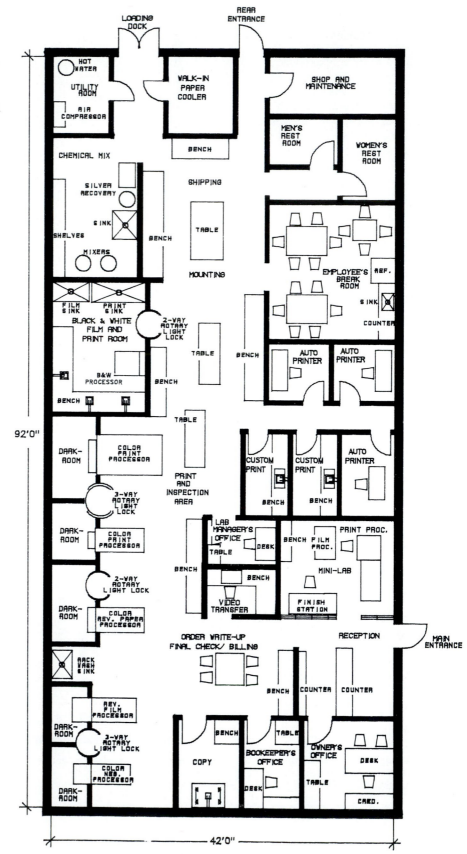

APPENDIX C Glossary

In photography, as in other trades and professions, common words are often used in a sense unfamiliar to most of us. Also, special words and expressions are used to describe tools, methods, and operations of the profession. This can lead to difficulties in communication. Misunderstandings can cause a waste of time and material, or even costly mistakes.

This glossary of photographic terms is intended to help architects, builders, and others who must interpret plans, drawings, specifications, etc.

activation processing A rapid-access method of processing for papers that have an incorporated developing agent in the emulsion. In the KODAK ROYALPRINT Processor, Model 417, the remainder of the process uses conventional solutions, and a print is obtained in less than a minute.

afterglow The glow from filaments of electric lamps or the phosphorescent glow from fluorescent tubes that remains after the current is switched off. See "White Light."

agitation Movement of photographic material in a solution to insure uniform action of the solution over the surfaces of the film or paper.

airbrush A small spray gun for retouching prints. Uses oil-free air at 30 to 40 psi (209 to 276 kPa).

basket A rectangular container used to hold papers or films during processing.

basket line A processor in which papers or films are transported in baskets through a line of tanks.

batch A number of prints or negatives processed together. Sensitized material coated with the same batch of emulsion. A volume of processing solution mixed from a specific amount of chemicals.

big enlargements Generally, photographic enlargements larger than 20 x 24 inches (50.8 X 60.9 centimetres). See "Photomurals."

B/W Black-and-white

blender Special apparatus for mixing liquid chemical concentrates.

blue-sensitive Describes photographic material that is sensitive only to ultraviolet radiation blue light.

"C" print A color print made from a color negative.

camera room In professional photography, the studio where photographs are taken. A room that houses a camera. Sometimes called a gallery.

chemical-mixing room A room adjacent to, or above, a processing room, used exclusively for mixing chemical solutions.

chemical-storage room Space adjacent to the chemical-mixing room for storing chemical supplies. Should be cool and dry.

chemical-storage tanks Tanks for storing mixed chemicals. These tanks may be heavy when full. Watch for overloading of the floor.

clean room A specially constructed room in which the incoming air is filtered with high-efficiency filters to remove dirt and dust. Airborne dust caused by movement within the room is removed before it can settle.

clean work station A bench or partly enclosed work area that is kept relatively dust-free by a stream of highly filtered air.

color balance The overall cast of color in a print or transparency. Correct color balance implies that the colors in the scene are reproduced realistically.

color negative A photographic image in which the density values are reversed and the colors are complementary to those in the original scene.

color print A color photographic image on a paper or polyester base.

color processing Processing color films or color papers. Requires different equipment and darkroom conditions from black-and-white work.

color sensitivity The sensitivity of an emulsion to light of different colors. Determines the safelighting, if any, that can be used in a darkroom. See "Panchromatic," "Orthochromatic," and "Blue-Sensitive."

commercial photography General professional photography, excluding portraiture, wedding photography, etc.

common plumbing Water pipes and drainpipes that serve two or more processing rooms or toilets.

condenser enlarger An enlarger that employs an optical condenser or condensers to project illumination on the easel.

constant-voltage transformer Voltage regulator. Used in color work to maintain voltage to equipment at the required level. Must be of adequate capacity for the current load.

contact print A print made by placing the negative in direct contact with printing paper; a print that is the same size as the negative.

contact printer A printing device designed for making contact prints.

continuous printing Making prints on rolls of photographic paper or film.

continuous processing Processing prints or negatives in rolls in specially designed machines.

copyboard An arrangement for holding copy flat while it is photographed.

copyboard illumination An arrangement of lights—usually four—for proper illumination of the copy being photographed.

copy camera A camera designed for photographing flat copy.

copying Photographing flat copy such as prints, maps, drawings, etc.

Cubitainer Trademark for a cube-shaped plastic container in which some chemical solutions are packaged. Large sizes weigh from 60 to 70 pounds (27 to 32 kg).

curtains Heavy black material used to exclude white light from darkrooms. See "Darkroom" and "Light Lock."

cyc A curved-radius cove, meant to create the impression of a seamless background. A cove or concave surface treatment in studios, usually formed where the floor meets a vertical wall. Also referred to as a cyclorama.

darkroom A special room for exposing, processing, or handling light-sensitive photographic materials. May be totally dark or illuminated with a safelight.

darkroom illumination Safelighting. Illumination of an intensity and color quality that does not adversely affect a particular type of sensitized photographic material.

darkroom sink A processing sink usually made from AISI Type 316 stainless steel or hard plastic material. Should either contain duckboards or have a fluted bottom for drainage of water and chemical solutions beneath tanks or trays.

darkroom walls Lighttight walls painted light beige or a similar color. Paint areas that are liable to be splashed with water or chemicals with epoxy paint.

Dataguide Kodak trademark for publications on photography. See *KODAK Black-and-White Darkroom DATAGUIDE* and *KODAK Color Darkroom DATAGUIDE* in Appendix D.

deep tank Tank for processing roll films. May be as deep as 50 inches (127 centimetres). Maximum cross section measures about 16 x 20 inches (40.6 X 50.8 centimetres). Made from stoneware, hard rubber, or stainless steel. A processing line of these tanks is heavy. Check floor strength.

Dektol Kodak trademark for photographic paper developer.

densitometer An instrument for measuring the density or opacity of a photographic image. May be electronic or visual.

developer A chemical solution for developing negatives and prints. Darkens the exposed silver halide in the emulsion.

developing position The part of a processing sink where development of film or paper takes place. Usually refers to manual processing.

developing tank Tank for developing photographic materials. May be made from hard rubber, stainless steel, or a hard plastic material. May be a separate unit or an integral part of a processing machine.

direct positive A positive image on paper or film made by exposing the material directly in the camera.

drum processor A film or paper processor in which the material is carried through a trough of solution by a revolving drum. Drum processors are used mainly for processing color prints.

dryer Apparatus or machine for drying photographic materials.

drying cabinet A heated cabinet used to dry films or prints.

drying rack A frame covered with muslin or plastic screening on which prints are laid out to dry.

drying room A heated, ventilated room used to dry prints or negatives.

dry mounting Mounting prints by means of a heat-sensitive sheet of tissue between the print and the mounting board.

dry-mounting press A press for dry-mounting prints. Usually operated manually. Heated electrically to about 210°F (98.9°C).

drum dryer A drum-type drying machine.

duckboards A framework of wooden, plastic, or stainless-steel bars placed in the bottom of a sink to permit drainage of water or chemical solutions beneath processing trays or tanks.

duplicate negative A negative made from an original negative, usually by means of an intermediate positive.

duplicating The reproduction of slides, negatives, and transparencies.

dye transfer print A print made by the dye-transfer process, a method of color printing through the use of separation negatives and matrices, which are dyed and placed on a receiver paper. The image is formed by diffusion of dyes into the paper.

easel A frame that holds a photographic material during exposure.

Ektachrome Kodak trademark for color reversal films and papers.

Ektacolor Kodak trademark for color negative papers, chemicals, and films.

Ektamatic Kodak trademark for processors and materials for stabilization processing. See "Stabilization Processing."

Ektaprint Kodak trademark for processing chemicals for color paper and for equipment and supplies for document copying.

enlargement A photographic image on paper or film that is larger than the original image; made by projection.

enlarger A device for making enlargements from negatives or transparencies. May be bench-operated or free-standing, vertical or horizontal. Check headroom required for large vertical models.

exhaust hood A hood—usually made from sheet metal—over a processing machine, a processing sink, or a chemical mixing tank to extract and dissipate heat, moisture, or fumes. The extracted air should be vented outdoors, not into the main exhaust of the ventilation system.

ferrotyping Imparting a high gloss to the surface of prints by pressing the emulsion of the paper onto a polished surface during drying. The surface may be chromium-plated stainless steel, glass, or a shiny plastic sheet.

ferrotyping machine A machine with a revolving heated drum onto which prints are pressed for ferrotyping or glazing. The surface of the drum is usually chromium-plated steel with a copper plating beneath the chromium.

film base The transparent flexible support on which film emulsions are coated.

film-drying cabinet A heated and ventilated cabinet in which films are dried.

film emulsion The light-sensitive coating on a film.

film hangers Stainless-steel frames used to suspend films during processing or washing.

film holder A flat lighttight sheath that holds two sheets of film for exposure in a view camera.

film-loading room A small, totally dark room used for loading film into film holders. Should be adjacent to the camera room or studio.

film-processing room A darkroom used for processing film. Most camera films are processed in total darkness.

finishing Retouching, hand coloring, lacquering, texturing, laminating, and mounting photographs.

finishing room A room where photographs are washed, dried, and finished.

fixer A chemical used to remove unexposed, undeveloped light-sensitive silver halide during processing.

fixing tank The container that holds the fixing solution. May be a separate unit or an integral part of a processing machine.

flexible-duct exhaust hood An exhaust hood with a flexible duct used above a chemical mixing tank to extract fumes.

floating lid A lid that floats on the surface of a processing solution stored in a tank; used to prevent evaporation and oxidation of the chemicals by the atmosphere.

gaseous burst A burst of nitrogen or air passed through a processing solution to provide agitation. Nitrogen is used in developers, air in most other solutions.

half-round trays Trough-shaped trays for manual processing of large prints.

hard water Water that contains an excessive amount of calcium salts—usually more than 150 parts per million of calcium carbonate.

heat exchanger Apparatus for heating or cooling water by an exchange of heat from hot water to cold water; generally used to temper water for controlling the temperature of processing solutions.

HEPA filters High-efficiency particulate air filters.

hood A sheet-metal hood placed above a processing tank, tray, or drying machine to extract chemical fumes, dust, and excessive water vapor.

horizontal enlarger An enlarger that projects an image horizontally instead of vertically (which is more common). Most often used for making big enlargements and photomurals.

hydrogen sulfide A poisonous gas with a disagreeable (rotten-eggs) odor given off by sulfide toning processes. Provide an air-extraction hood above the toning tray or tank.

hypo Sodium thiosulfate. A common name for the fixing solution in photographic processes.

hypo tank A container used for fixing solutions. Hypo is usually an acid solution that requires a tank made from stainless steel, hard rubber, or plastic.

I.D. camera A special camera used for making identification pictures.

industrial photography Photography applied principally to industry.

inspection Examining photographs for quality and defects.

internegative The negative made as an intermediate stage in a photographic reproduction process.

interpositive The positive made as an intermediate stage in a photographic reproduction process. An intermediate positive in negative reproduction.

Kodacolor Gold Kodak trademarks for camera film for negative-positive color photography.

Kodachrome Kodak trademark for camera film for making color slides or transparencies by reversal processing.

Kodalith Kodak trademark for high-contrast materials used mainly in photo-mechanical reproduction.

Kodalith film processor A roller-transport machine for processing KODALITH Films or similar films.

lacquering The process of covering the surface of prints to protect the surface, to cover retouching marks, or to enhance the surface texture. Lacquers are volatile and flammable; provide a properly designed spray booth.

laminar airflow Air that flows in one direction only, without cross currents or eddies. A system of clean-room ventilation in which a laminar airflow is forced through the room to carry away particles. A non-turbulent air movement.

laminating Sandwiching photographs between sheets of adhesive plastic; usually done by a heat-sealing process.

light lock A lighttight darkroom entrance that consists of two doors, one of which always remains closed to prevent white light from entering the room. See also "Revolving Light Lock."

light room An area not involved in photographic printing or processing.

light trap A type of darkroom entrance that is not as secure as a light lock; usually used in black-and-white printing rooms.

lighttight Applies to a container or a room that does not admit light that would fog a photographic material.

lighttight drawer A drawer for temporary keeping of photographic material, usually situated in a darkroom bench. The lighttight cover slides into place as the drawer is closed. Also known as a light safe.

location Usually a photographic site away from the studio.

long rolls Rolls of film longer than the standard length commonly used in roll-film cameras.

matte-black paint A dull black paint for reducing reflection of light from interior surfaces of cameras, light traps, walls, etc.

matt dryer A machine for drying papers with a surface other than glossy.

mechanized processing Processing photographic materials in machines.

mix A batch of mixed chemical solution.

mounting press See "Dry-Mounting Press."

mural A wall-sized photograph. A large print, usually mounted on a wall.

negative A photographic image in which the tones are reversed from those in the original scene. Usually consists of metallic silver or dyes on transparent film, but may also be on glass or paper.

negative processing The operation of processing film to produce negatives. May be black-and-white or color, manual or mechanized.

negative retouching The operation of improving or altering an image by hand-work on the negative.

nitrogen burst A method of agitating photographic solutions by means of bursts of nitrogen gas under pressure.

optical printer A printing machine that employs a lens to form an image. Usually a piece of equipment used for high-volume production of prints in rolls.

original The negative or transparency material exposed in the camera, as opposed to a copy or duplicate.

order control A work space where incoming and outgoing orders are controlled.

orthochromatic Describes a photographic material sensitive to ultraviolet radiation and blue and green light, but insensitive to red light.

oxidation A chemical change caused by combination with oxygen. Photographic chemicals, particularly developers, become oxidized by exposure to the air. Overly vigorous stirring during mixing causes oxidation.

paddle A wood or stainless-steel implement used to agitate prints in processing solutions.

panchromatic Describes a photographic material that is sensitive to light of all colors; may be abbreviated "pan." Panchromatic materials are handled in total darkness.

paper processing Print processing. May be either manual or mechanized.

pass-through A device for transferring wet prints from the darkroom to the finishing room without allowing light to enter the darkroom. May also be used for transferring exposed material from a printing room to a processing room.

photolab Photographic processing laboratory.

photometry The measurement of light intensities to determine correct exposure for films, papers, and plates.

photomural A large print for decoration or display. Usually covers a large part of a wall or a whole wall. See "Mural."

plastic pipe Known as CPVP or PVC, can be used for chemical lines and similar uses. PVC has temperature limitations. The use of plastic pipe (PVC) is subject to local plumbing codes.

point of use The processing machine or processing sink to which chemical solutions are distributed by means of pipelines.

precise-temp control A temperature-control unit for regulating the temperature of processing solutions or water.

printing A general term for making photographic prints either by contact or by enlargement.

printing frame A frame with glass and a spring back used for making contact prints.

processing Development and other steps such as fixing and bleaching that make a photographic image on film or paper visible and stable.

processing room A darkroom for processing negatives or prints. See "Darkroom."

processing tanks Containers that hold processing solutions. May be parts of a machine or separate units. Capacities range from about 1 pint (0.5 litres) to 40 gallons (151 litres).

proof A print used for inspection or approval by a customer before a final print is made.

proofing Making proof prints. May be carried out in subdued room light or as a normal printing operation in the darkroom.

quarry tile A type of ceramic tile suitable for floors in wet locations, such as the chemical-mixing room. To avoid a slippery surface, use quarry tile with an abrasive surface.

quick disconnect A fitting on a line used for transferring chemicals (usually to a floor above) from the chemical-mixing room. Chemicals sent through this fitting will not flow backwards onto the floor.

recirculation unit A device for tempering and circulating processing solutions or water.

recording thermometer A thermometer connected to a processing machine that records variations in developer temperature.

RC Abbreviation of resin-coated; used to describe water-resistant photographic printing paper.

replenishment Maintaining solution activity by adding fresh solution, usually slightly different in chemical composition or concentration from the working solution.

residual chemicals Chemicals that remain in a photographic material after processing.

retouching Improving a negative, print, or transparency by handwork. See "Negative Retouching."

revolving light lock Two large vertical cylinders, one of which revolves within the other. With suitably placed openings or doorways, the arrangement permits access to a darkroom without admitting light from the outside.

roller transport A method of transporting sheets or rolls of photographic material through a processing machine by means of multiple rollers. KODAK VERSAMAT and KODALITH Processors are roller-transport processors.

roll films Standard lengths of film spooled for use in a camera.

roll-paper air dryer A machine for drying rolls of photographic prints by air impingement.

roll-paper cutter A machine for separating rolls of prints into individual prints.

roll-paper dryer A machine for drying rolls of photographic prints. Usually a drum-type machine.

safelight filter A filter that transmits only light that does not significantly affect a light-sensitive material. The color and density must suit the material being handled.

safelighting Darkroom illumination of a color and intensity that does not significantly affect a light-sensitive material.

safelight lamp A fixture that contains a bulb and a safelight filter. Different types are available for hanging close to the ceiling or near a processing sink, or for direct connection to a wall socket for indirect or direct illumination.

sensitized goods Light-sensitive photographic materials; films, papers, and plates.

short stop Stop bath.

silver recovery Recovering metallic silver from photographic solutions electrolytically or by refining precipitates or sludges from the effluent.

soft water Water that contains a minimum of calcium and magnesium salts. Very soft water contains considerably less than 40 ppm of calcium salts. Very soft water is generally unsuitable for processing photographic materials, particularly for washing, because it softens and swells gelatin.

spotting Retouching small spots on prints with dyes or pencils so that they blend into the surrounding area.

spray booth A three-sided enclosure used in print lacquering that prevents overspray from polluting the atmosphere of work rooms. The booth should be equipped with an exhaust fan and electrical fittings protected against the risk of explosion.

stabilization processing A fast processing method in which the silver halides that remain in the material after development are not removed, but are converted to only relatively stable, colorless compounds.

stabilization processor A small machine for processing prints by stabilization.

stop bath A bath used after development to stop the action of the developer and reduce carryover of developer into the other solutions.

storage tank A tank for storing mixed chemical solutions; may be plastic, stainless steel, or earthenware. Capacities may range from 10 to 1000 gallons (37.8 to 3785 litres).

studio In large establishments, the camera room where photographs are taken; in small portrait businesses, may refer to the whole premises.

sulfide toning A process for converting metallic silver in an image to a sulfide compound to change the image tone or protect the image.

switch lock A device placed over a switch to prevent workers from accidentally turning on white lights in a darkroom.

tempered water Water held at a specific temperature that maintains the temperature of processing solutions. Control of temperature within plus or minus 0.5°F (0.3°C) is often required for solutions such as developers.

toning Altering the color of a black-and-white image by chemical means; treatment of a black-and-white print or film to protect the image during display or archival storage. Toning includes treatment that protects an image without changing its color.

transparency A processed photographic film in which the image is positive; viewed by transmitted illumination.

tray processing Manual processing of films or papers in trays.

tungsten light Light emitted by ordinary incandescent light bulbs.

two-bath fixing An efficient method of fixing prints or negatives that increases the capacity of the fixer and keeps the second bath relatively fresh. Two baths are used in succession: The first bath removes most of the soluble undeveloped silver halide; the second bath completes fixing.

Twin Check A double set of labels used to keep a job together (one label for film; the other for the job envelope).

vacuum back A means of holding film in a process camera by suction.

vacuum board A copyboard that holds the copy or other material in place by suction.

vacuum breaker A fitting to prevent contaminated water from being siphoned into the water lines if the main supply fails or is shut off. This is often a requirement of local plumbing codes.

Vericolor Kodak trademark for professional color negative films.

Versamat Kodak trademark for roller-transport machines for processing continuous-tone black-and-white films.

vertical copy camera A copy camera with a horizontal copyboard. The camera body and lens or the copyboard can be adjusted vertically.

vertical enlarger An enlarger with a horizontal baseboard. The lens and lamphouse assembly are adjusted vertically.

view camera A large-format camera used mainly in commercial photography; normally mounted on a stand or tripod.

viewer A diffused light source for inspecting or judging transparencies or negatives. For critical judging of color, see ANSI Standard PH2.30-1985, *Viewing Conditions—Photographic Prints, Transparencies, and Photomechanical Reproductions.*

viewing board An illuminated board for viewing prints.

voltage regulator A constant-voltage transformer for maintaining a specific voltage for color printing or other applications that require a constant color temperature and light intensity.

washer See "Washing Tank."

washing tank A tank that provides constantly changing water to wash residual processing chemicals from photographic materials. May be a separate unit or an integral part of a processing machine.

water aeration Treatment of incoming water below 50°F (10°C) to eliminate air bubbles, which can cling to the surface of films and papers and interfere with processing and washing.

water chiller A device used to reduce the temperature of the incoming water supply to a suitable level.

water jacket A space surrounding a processing tank in which tempered water circulates to maintain the proper solution temperature.

white light Normal room light provided in a darkroom. Do not install fluorescent tubes in a film-processing darkroom because the afterglow may affect fast photographic materials.

white-light switch The switch that controls the white light in a darkroom; should be protected against accidental use. See "Switch Lock."

Index

More Information

The following Kodak publications offer more information on the subjects discussed in this book.

KODAK Publication	Code
Gaseous-Burst Agitation in Processing	E-57
Finishing Prints on KODAK Water-Resistant Papers	E-67
Photographic Retouching	E-97
KODAK EKTACOLOR PORTRA Papers	E-140
KODAK EKTACOLOR SUPRA Papers	E-141
KODAK EKTACOLOR ULTRA Paper	E-142
KODAK Display and Print Materials for Process RA-4	E-143
Quality Enlarging with KODAK Black-and-White Papers	G-1
CHOICES—Choosing the Right Silver-Recovery Method for Your Needs	J-21
CHOICES—Choosing the Right Chemicals for Processing KODAK Color Papers and Materials in Professional Finishing Laboratories	J-27
The Use of Water in Photographic Processing	J-53

KODAK Publication	Code
Disposal and Treatment of Photographic Effluent	J-55
Chemicals for a Cleaner Environment—Processes RA-4 and C-41	J-100
O.S.H.A. and O.S.H.A. Standards	J-101
Regulations Affecting the Disposal of Photographic Processing Solutions	J-102
How Safe Is Your Safelight?	K-4
KODAK Color Darkroom DATAGUIDE	R-19
KODAK Black-and-White Darkroom DATAGUIDE	R-20

These publications are available from dealers who sell Kodak products, or you can order them directly from Kodak through the order form in the *KODAK Index to Photographic Information,* KODAK Publication No. L-1. To obtain a copy of L-1, send your request with $1 to Eastman Kodak Company, Department 412L, Rochester, New York 14560-0532.